CW01212711

KATE MOSS

THIS IS A CARLTON BOOK

Published in 2014 by Carlton Books Limited
20 Mortimer Street
London W1T 3JW

10 9 8 7 6 5 4 3 2 1

Text and Design © Carlton Books Ltd 2014

All rights reserved. This book is sold subject to the condition that it may not be reproduced, stored in a retrieval system or transmitted in any form or by any means, electronic, mechanical, photocopying, recording or otherwise without the publisher's prior consent.

A CIP catalogue record for this book is available from the British Library.

ISBN 978 1 78097 457 6

Printed in Dubai

KATE MOSS

Chris Roberts

CARLTON
BOOKS

Contents

INTRODUCTION		**6**
Chapter 1:	**SUBURBAN HEIGHTS**	**12**
Chapter 2:	**"THOSE WONDERFUL CHEEKBONES"**	**22**
Chapter 3:	**"PRETTY WILD"**	**34**
Chapter 4:	**OBSESSION**	**44**
Chapter 5:	**"HERE'S JOHNNY!"**	**54**
Chapter 6:	**"EXCESSIVE PARTYING"**	**72**
Chapter 7:	**DAZED & CONFUSED**	**84**
Chapter 8:	**THE BEAUTIFUL & DAMNED**	**96**
Chapter 9:	**ROCK & ROLL CIRCUS**	**106**
Chapter 10:	**DON'T CALL IT A COMEBACK**	**122**
Chapter 11:	**THE BRIDE STRIPPED BARE**	**132**
INDEX		**142**

Opposite: Prints of the iconic Kate Moss by British grafitti artist Banksy, inspired by Andy Warhol's portraits of Marilyn Monroe.

Introduction

"**WHEN I WALK ON SET,**" Kate Moss told David Bowie as the two icons conversed in New York for *Q* magazine in 2003, "they can put anything onto me and I can become that image: I feel I've accomplished being a chameleon, being whoever they want me to be." Bowie asked, "Why would you take on the identity that someone is dictating to you? Do you feel you're earning their affection or their love in some way?" "Oh!" muttered Kate. "I don't know… maybe…"

As she celebrates her 40th birthday, Kate Moss, a model since she was a schoolgirl, is a brand and an industry. "The Waif" has continually expanded her empire; "The Wealth" would be a more accurate nickname. Yet she has become so much more than the five-foot-seven facts.

To the fashion world, she is nothing less than a goddess, and she has pursued the chimera of rock and roll more vigorously than most musicians. Astutely reticent for many years (in words, if not in actions: she is a supreme socialite) she has allowed the mythology surrounding her to be nurtured, the flames to be fanned, like an old-time screen star shifted to the heartless heart of the white-noise-harsh-light celebrity age. She has been discussed as if not human, her magnetic qualities as a muse to artists and photographers (from Banksy to Richard Prince, Bruce Weber to Richard Avedon), analyzed with phrases like "the Venus of our era", "dirty realism" and "that's so Kate", with quotes from Jean Baudrillard, Andy Warhol and Norman Mailer scattered liberally. She's been the face of grunge and Cool Britannia and launched a thousand expensive accessories. As long ago as 1999, Julie Burchill wrote that, "Kate Moss has grown up in public into one of the most singular and shimmering icons our damp little island has ever produced." She's stumbled between high-profile romances that ranged from Hollywood glamour to Britpop-seedy. Nonetheless, she seemed untouchable for years until a very public media (symbolic) crucifixion, from

This page We ARE amused: Kate enjoys being a part of the British Fashion Awards at the Royal Courts of Justice, London, in December 2009

INTRODUCTION

Opposite Wearing the work of (close friend) Stella McCartney for Chloé, October 1997.

Overleaf Purple reign: Kate models for Longchamp in 2008.

which she emerged not only intact but more powerful and influential than ever, a wife, a mother, a glittering institution, regal but rough-edged.

Since opportunity fell into her lap in her early teens, she has worked and played hard. Kate Moss is, photographer David Bailey has said, "The kind of girl you wished lived next door, but she's never going to. She's almost in reach, but she's not in reach." Discussing his choice of Moss to re-create Olympia on his 2010 album cover, Bryan Ferry told me, "She's perfect for this. She has the strength of image, as well as the beauty. Of course, the original Manet is a very powerful picture. I was very taken by it, as an art student. I'd think: how and why is this so strong? It's all in the eye of the beholder – her arrogance, haughtiness. She's kind of staring you out, demanding: who do you think you are? And yet, for its day, it had a kind of, I guess, tartiness, too. Very shocking in its era."

Kate Moss has frequently shocked the easily shockable. At first, it was images of her that lit the fuse, sparking firestorms about "heroin chic" and anorexia. But whereas most models – indeed most young stars – burn out fast, she, despite a less-than-wholesome lifestyle, somehow survived and sustained. This Zelig of modern fame saw the supermodel Eighties become the British Invasion Nineties, then the narcotized Noughties become the Carphone Warehouse Now. She counted them all out and she counted them all back. From Depp to Doherty, from Croydon to the catwalk to Primrose Hill to the Cotswolds, the Waif grew and grew, yet remains elusive, a source of fascination. Last year alone, according to *Forbes*, she made a cool $9 million.

Kate Moss once quoted Jean Cocteau: "The more visible they make me, the less visible I become." That doesn't stop everybody looking: the images in this book tell their own multiple versions of her story. To steal a Goethe quote used by Ferry to underline his aforementioned appropriation of this at-first accidental icon: "The eternal feminine leads us on…"

KATE MOSS
SUBURBAN HEIGHTS

SUBURBAN HEIGHTS

ON 1 APRIL 2013, the *Croydon Advertiser* ran the full-page

story that the planned new local shopping centre was to erect a statue of Kate Moss as its focal point. The Australian retail giant Westfield had, reported the newspaper, commissioned the statue "to cheer up the town after reading an article in the *Daily Mail*, which claimed that Croydon is the second unhappiest place to live in Britain". Sculptor Marc Quinn had been asked to re-create his 18-carat gold monument to Kate as part of an intended "Croydon facelift".

Around now, what began as a peculiar story entered the realms of the (more) absurd, as claims were made that the centre was to be named the Kate Moss Mega-Mall and that a petition to drop Kate in favour of Darth Vader (because the actor who'd played him in *Star Wars*, Dave Prowse, came from Croydon) was gathering momentum. A statue of the diminutive actor and comedian Ronnie Corbett, also a resident, was championed by others, "because it would save money". One only had to check the date of the humorous article before accepting that, even in the strange and realism-defying life of Kate Moss, this was a leap of the imagination too far.

Page 12 Speaking in tongues: Kate refuses to let her spirits sink while at the *Titanic* film premiere, in November 1997.

Below Artist Marc Quinn displays Kate-inspired drawings at his Finsbury Park studio in London, 2007. He once cast an ice sculpture of her. It melted.

Right *Siren*, a lifesize statue of Kate by Marc Quinn was first exhibited in the British Museum in 2008. It was the largest gold statue created since the days of ancient Egypt.

It's often declared that Moss is indeed the most famous person to have been born in Croydon. A few might point out that the large town nine miles south of Charing Cross, hit by riots in 2011, has other claims to celebrity. In the literary arena, D.H. Lawrence, Emile Zola and Sir Arthur Conan Doyle have resided there or nearby (it is mentioned in some Sherlock Holmes stories), and Sir John Betjeman set not one but two poems in this slice of suburbia. Music? The composer Samuel Coleridge-Taylor (1875–1912) – not to be confused with the similarly named poet, whose former residence Kate now owns – grew up there. One of Croydon's pubs saw the debut gig of the Electric Light Orchestra (ELO) in 1972. It is home to the Brit School, which, in recent times, has churned out all-conquering pop stars from Adele and Jessie J to Leona Lewis and Amy Winehouse. That's not all. Long-running TV show *The Bill* was filmed there, and it still serves as the location of *Peep Show*. It boasts Crystal Palace football club and the concert venue Fairfield Halls, the latter having played host to The Beatles and Tom Jones. It was also used to film a scene in *The Da Vinci Code*. And, yes, its shopping centres are legendary.

Kate Moss was born there on 16 January 1974. But when we say "there", let's remember Croydon ("the British Newark", according to one American fan) is a large place made up of different areas and contrasting ambiences. In his book *Addicted to Love*, Fred Vermorel wrote, "Forget Croydon: that is a fantasy she likes to spread as much as the media does… Croydon may be the general area, and convenient shorthand, but Sanderstead – suburbia – is what's inside her. It accounts for both her timidity and her nihilism, and for her 'state of semi-detachment'."

15

SUBURBAN HEIGHTS

Right Young Kate, the daughter of a travel agent and a barmaid, grew up in Church Way in suburban Sanderstead, part of Croydon, south London.

Her mother Linda Shepherd (born 1947), a barmaid and sometime shop worker, was a local girl, born a mile from central Croydon. Her father Peter Edward Moss (born 1944) worked with American airline Pan Am, as a ticket clerk. Having lived near to each other for many years without meeting, they did so at a mutual friend's 21st birthday party. They married on Saturday 17 April 1971 at the fourteenth-century church of St Mary's in Beddington. The wedding certificate grandly described 23-year-old Linda's occupation as "boutique manageress". She wore not a wedding dress but – unconventionally for the time – a neat suit.

Daughter Kate arrived less than three years later, weighing a not-especially-waifish seven pounds and ten ounces, with St Mary's Maternity Hospital in Croydon her first view of the world. Her second was her parents' semi-detached house with a garden (a short walk from where Linda had grown up) in Pagehurst Road, Addiscombe, just north-east of Croydon. Soon they moved to Church Way in Sanderstead, where they had three bedrooms and the back garden merged with lush ancient woodland.

Peter was considered rather debonair, with his job offering opportunities for travel beyond the experience of most of their friends: a mere ten months after her birth, Kate was taken abroad for the first time. Two years later she had a brother, Nicholas. At playschool, Kate was called "Katy": it's been said she was "a sparkling child… she wasn't naughty". She showed an early fondness for painting. At age five, there came the landmark of the first day at school proper: the highly thought-of Ridgeway Primary.

A former headmaster has recalled her as "pleasant but not particularly noteworthy", though it's asking a lot of a former headmaster to remember every five-year-old and it's asking even more of a five-year-old to be particularly noteworthy. As the years passed, Kate had her first (failed) attempt to pierce her ears with a sewing needle, her first radical haircut and her first appearances in school plays and ballet performances. She was, however, shy in front of audiences.

In her last year at Ridgeway Primary, she was taken on a school trip to France. If some of the girls found it overwhelming, Kate, already familiar with travel, thanks to her dad's access to bargain flights, did not. In fact, the Moss family's exotic holidays were an outstanding feature of Kate's youth: she'd go everywhere from Florida to the Caribbean. Aged just six, she'd been on a family break to Disney World in Orlando. It's often been said of the adult Moss that she is an unorthodox mix of vulnerability and bravado. Perhaps the youthful jetting around the world explains just some of the latter – a degree of fearlessness.

At age 13, in 1986, Kate entered Riddlesworth High, the local – mostly "respectable", middle-class – secondary school. Brother Nick started at the school three years later: they'd fight, with one scrap ending up with her dressing him in girls' clothes, though usually their rows, however rough, ended in forgiving laughter. Kate and friends would themselves dress up in heels and make-up and pretend – with unwitting foresight in her case – that they were models. Academically, Kate's favourite subjects were English and Drama, primarily because, in her opinion, "you never had to do anything". And it seems she didn't. Out of eight GCSEs, she scraped a C in one (Science), receiving Ds or worse in all the others. Already, the figure that launched a thousand magazine covers was slim and flat-chested: "They used to call me 'Stick' and take the piss." Another nickname from her schooldays that really did stick in those years was "Mossy" or "Mosschops". Linda has said, "I'm sure she dreamed of being an actress. She was always putting on little plays and performances with her chums." One former school-friend has sniffed, "For me, she was very ordinary. She didn't stand out." She was good at sport, however, playing for the school netball team and, as a sprinter, becoming captain of the athletics team. In adulthood, she's gone out of her way to play these achievements down, as if being fit and competitive doesn't suit her rock-and-roll persona. Perhaps the lack of academic excellence could be partly explained by her tendency now to skip school and – despite the sportiness – embrace the conventional rite-of-passage gateways to hedonism: booze, fags and pot. "I went to school to socialize. I never did my homework… We used to go to people's homes and steal their mum's booze on the way to school," she's said. "We used to go to Tesco and nick things – well, I never would do it but my friends used to and I'd stand there and

Below Kate's mother has said that her daughter "dreamed of being an actress. She was always putting on little plays and performances…"

18

SUBURBAN HEIGHTS

Opposite Kate posing with her mother Linda (and, of course, drinks) at the launch of Kate's Topshop line at the store's Oxford Circus branch in London, 2007.

watch." Kate would hang out at Sanderstead Youth Club, as there were then no pubs in the immediate area. Friday and Saturday nights meant a two-mile trip to Purley, supping cider in the park with the "bad boys". Her parents, it seems, were extremely liberal. She's elaborated, halfway between confession and a boast: "Literally, my parents let us do whatever we wanted. I was smoking and drinking in front of them when I was 13. I'd go to parties and come in at three in the morning." What she says next is illuminating but raises questions when you consider her later life. "It's actually worked to my benefit – you end up thinking for yourself because you know you're not rebelling against anything." She puts smoking pot down to, "South London, innit? Everyone at school was going, 'Oh my God, she's a junkie', and I was just: oh, they don't know what they're talking about. I suppose I was quite blasé about everything. Everyone was just making a fuss about nothing." Kate has also stated, in a rather self-glamorizing manner: "I was a rebel who only thought of the next day. I didn't think ahead, except in terms of the next day's provocation."

That last sentence could almost be Moss's deflective mantra in years to come. Right now, though, all was not rosy at the liberal home. Some of her parents' "laissez-faire" attitude might have been brought on by the fact that they were distracted by emotional upheaval of their own. Peter and Linda were coming to acknowledge that, after 17 years,

Right Kate with her brother Nick in 2010: his modelling career didn't match hers for longevity.

49

SUBURBAN HEIGHTS

SUBURBAN HEIGHTS

Opposite In 2003 Kate met long-time idol David Bowie for a *Q* magazine cover shoot – by now, she knew a thing or two about reinvention and rock'n'roll herself.

Below Bowie performing as Ziggy Stardust. Kate became a David Bowie fan as a child – her dad gave her an *Aladdin Sane* poster when she was 11, which she put on her wall.

their marriage was done for. When Linda met another man, Geoff Collmann, and asked for a separation, the decision was effectively taken. Kate's mother has drawn much flak from the media during her daughter's years of fame, with amateur psychologists blaming any stumble or mis-step by the model on Linda, assuming that she behaved more like an older sister than a mother. Taking a job in her late thirties at a local brasserie, Linda met her new chap and saw him as an opposite to her "safe" husband. The "trial" separation from Peter only confirmed that their marriage was over. As the family home was sold, Peter moved to nearby Purley, and Linda (with Geoff) to Forestdale, another Croydon suburb. There were inevitable disagreements over custody of their children – Kate was 14, Nick 12. Kate has recalled, "A man came round and asked us which of them I wanted to live with. I said my mum, and my brother said my dad." The results were less black and white than that. The two Moss children each stayed over at the other parent's home from time to time. Linda has always stated that Kate dealt with the turmoil – and subsequent divorce – stoically. "She came through it well." Peter continued to be the parent most likely to show up at parent-teacher evenings and school plays and suchlike. Yet Kate must have run the gamut of emotions. Again, many have rather glibly blamed her volatility on her "broken home".

There can be no pretending that her engagement with school didn't nosedive after the divorce. Restless feisty would-be rebels are ten a penny among teenagers, and Kate wasn't about to challenge the statistics. Heavy black eyeliner and provocatively short skirts came in. She got into the music of David Bowie, falling for "Rock'n'Roll Suicide", "Life On Mars?" and "Golden Years". (It was her father who'd pointed the way, giving Kate an *Aladdin Sane* poster when she was 11.) Much further down the road, of course, she was to take part in an intriguing interview and photo shoot with Bowie.

When she was 14, on another glamorous holiday in the Bahamas with her father and brother, she lost her virginity on the beach to – so her version runs – a handsome young American. (Others scoff at her tale, claiming that "Croydon" had deflowered her first.) It was August 1988 and Peter had planned the holiday as a trip to take his and his kids' minds off the divorce that he'd filed for, citing Geoff Collmann as co-respondent. Kate may have been enjoying her first holiday fling, but as the fortnight's holiday drew to a close, Peter grew anxious about the return trip via New York. His mother, a widow for years, was getting married again. It was essential for them to be back in Croydon in time for the ceremony. Just when the airline travel expert didn't need it, there was a hold-up with the flight: they were going to be stuck at JFK airport overnight. Then a fortuitous respite came. Three tickets back to London became available: one in first class, one in business class, one in economy. Confident of his children's maturity, Peter snapped them up, and Kate went in economy. Peter, now remarried, could hardly have realized that the decision to get on that flight was to change his daughter's life irrevocably and beyond all plausibility. On that flight, Kate Moss – the model – was "discovered"; some might say, "invented". She wouldn't be flying in economy for much longer.

21

KATE MOSS
"THOSE WONDERFUL CHEEKBONES"

"THOSE WONDERFUL CHEEKBONES"

"HALFWAY THROUGH the flight, my meal had come and I was listening to my Walkman," Kate Moss has recalled. "A man came over to where I was sitting and said, 'Excuse me.' I was like: 'What? What do you want??' He said, 'My sister owns a modelling agency and she'd like to speak to you.' We ended up having this chat and, to this, day she – Sarah Doukas – is still my agent."

Kate being "discovered" at an airport, aged 14, has become a well-known, often-repeated, modern-day fairy tale, seized on by millions of young women as a symbol of hope and the possibility that anybody can be transformed from a nobody to a somebody, from a loser to a winner, from a schoolgirl to a star, overnight. It's the kind of fantasy that ultimately prompts as much heartache as elevation in those dreaming of release from the everyday and mundane. Yet it did happen, for Moss. She's been canny enough to emphasize this "normal girl plucked from nowhere" watershed moment in her life. Ever so humble.

Sarah Doukas, then 35, was flying back to London with her brother Simon Chambers and her six-year-old daughter Noelle. She was returning to her relatively new modelling agency Storm. She had worked in the industry for years but, a year previously, boldly launched her own agency. "Boldly" in so much as, being friends with Richard Branson's sister Lindy, she had bagged a £250,000 interest-free loan from the Virgin tycoon. He gave her offices in Kensington too. Now she just needed models, and her niche, as she perceived it, was to find fresh faces with personality and imperfections to counter the surfeit of hyper-real airbrushed perfection that had ruled the Eighties thus far.

Things weren't going as well as she'd hoped just yet, though one teenager – a Rachel Hunter – showed promise. This talent-search visit to America had proven fruitless. "I was in such a bad mood… desperate to get home," Doukas has said. "The last thing I'd said to my brother before the airport was, "I never want to see another model again." And then, at JFK, while chatting on the phone, she saw one. Or saw a face that she thought – knew – could be one. She saw Kate Moss and was a believer. "I saw this wonderful face in a sea of other faces. I saw those wonderful cheekbones. Then she disappeared. I knew she had to be on our flight because she'd been at the same check-in desk… I was searching for her…" On the plane, she sent her brother to trace the girl and ask her, in the classic tradition, if she'd thought about modelling. When Simon introduced himself, Kate was young and impressionable enough not to run a mile (which would have been tricky, anyway, in economy class). He explained that his sister ran an agency.

To the potentially cheesy inquiry as to whether she had ever considered modelling, Kate, at just over

Page 22 Kate throwing shapes as her star rises in 1992.

Below Sarah Doukas of Storm modelling agency "discovered" Kate at JFK airport, propelling her to fame.

Opposite Photographed in April 1992, the young model is already exuding confidence.

"THOSE WONDERFUL CHEEKBONES"

Left A 15-year-old Kate takes to the catwalk for John Galliano for Autumn/Winter 1989, making her debut for the controversial designer.

five foot six, replied, "No! I'm too small!" But the Storm duo didn't care about that: they felt she had that special something – "charisma", Chambers called it – and gave her his business card. Did Kate leap up excitedly and tell her father and brother? She did not. She harboured her secret like a treasure until they landed at Gatwick airport. In response, Peter and Nick burst out laughing, and so did she. Home at her mother's, she shared the news, and Linda, too, found it implausible. How could skinny little Kate possibly match up to the supermodels of the day – the Cindy Crawfords, the Christie Brinkleys, the Yasmin Le Bons?

Yet Kate kept thinking about the approach and, although her mother tried to dampen her expectations for fear of disappointment and scam-merchants, she wanted to pursue the matter. At the very least, she thought, it might be "a laugh". So, to Doukas' delight, they phoned Storm and made an appointment. A few days later Linda and the suntanned Kate took the train to London. At that first meeting in Kensington, Sarah impressed. She acknowledged Kate's (lack of) height but pointed out that she, at five foot two, had herself worked as a model for seven years. She even sent Kate to several castings that very day. The buzz of the office seemed alien and glamorous to the Mosses. The castings led to nothing, which disheartened Linda, but Kate had listened to Doukas intently and learned quickly that there would be early rejections to be surmounted. When Storm arranged a photo shoot to start her portfolio, Kate went to the session alone. Linda, as usual, let her get on with it. "I'm not traipsing around London like that again. It's a nightmare."

Kate was understandably excited and nervous, arriving at an apartment in London's Earls Court for her first ever shoot on 25 October. Photographer David Ross, just 22 himself, was less thrilled. He had an arrangement with Storm whereby he photographed their new girls for them and thus built up his own portfolio.

A communication screw-up meant he wasn't expecting her when Kate rang the bell. "I opened the door to see this scrawny little child," he's said. "I thought it was some girl who'd pressed the wrong buzzer and was trying to find her mum..." He was startled to learn she'd come all the way from Croydon by herself, and added that he couldn't take her photos because she was so young and unaccompanied. She'd have to return the next day with either a parent or friend. Kate was upset but, sure enough, turned up the next day. With a friend. She brought changes of outfits: a sweater, a coat, a hat, trousers and pumps. And a scrunchie. Ross did what he could but didn't deem the results remotely commercial. "She was a 14-year-old schoolgirl," he told a biographer. "She was trying, God bless her, but she didn't have a clue." They took shots on the roof, then on the street, with Kate holding the reflector herself.

The photographs may not have rocked the world, but Kate was nevertheless signed for castings. Her first came with teen magazine *Mizz*. She was paid £150 – "I was like, wow!" – and relished telling her schoolmates about it. Soon she was skipping school regularly, changing out of her uniform on the train, bumbling her way to wherever a casting was taking place. She did a shoot for *Brides* magazine when she was 15. She began to realize the job was tiring and demoralizing at times, full of competitiveness and rejections, yet, being friendly and co-operative, and striving to get on with everyone she met, she showed herself to be "bookable". Kate Moss's often-cited "overnight success" took some time to happen – there were naïve wrong turns, dodgy photographers asking her to take her top off, a trauma or two, people telling her she had bandy legs, a gap in her front teeth.

Doukas was championing her ardently. "I saw her and instantly knew I'd struck gold. This 14-year-old girl with amazing bone structure was a vision. Yes, she was smaller than any model on any agency's books, especially in the era of the supermodel, but I knew she had something." And at the tail end of 1989 came the hugely significant session with the photographer Corinne Day, which most deem the moment at which Moss's career really began. Prior to that, the year had seen her take to the London catwalk for the first time, placed there by John Galliano. The now-notorious designer, a St Martin's College graduate, was eager to make a name for himself and was already making waves with eye-catching, provocative collections. He had launched his own label and been hailed as British Designer of the Year in 1987. He was loudly advocating change and testing boundaries in what he saw as an increasingly sterile fashion industry. He was soon to head to Paris and fame and acclaim with Christian Dior, but in 1989 he was casting his final show as a London resident.

Kate wasn't an obvious choice – "too short" came the refrain – but he agreed with Storm that she had "something", plus she was willing to take the high-profile gig for her train fare. Galliano's clothes had to be adjusted to her size. Backstage, the other models looked at her oddly, but found her nervous chattering charming. And when she set foot on the runway, there came the transformation. She dazzled. In quirky Union Jack outfits, spectacular hats and lofty heels, she stood out from the other girls. Galliano was to book her for his Paris debut the next Spring. Influential others, too, had noticed her energy.

Corinne Day had worked as a young model herself and once admitted that there was an element of "narcissism" in her fascination with Moss. She was

Above Culture-clash: Kate modelling another provocative Galliano outfit for Spring/Summer 1993.

"THOSE WONDERFUL CHEEKBONES"

commissioned by *The Face*, a magazine that was itself craving change as the decade ended, seeking the shock of the new. As a photographer, she was looking for nothing less than the face of a new generation. Kate was again, blessed by fortune, in the right place at the right time. With the right cheekbones.

 She'd been working with Day frequently for some months, the pair bonding. Shots had been taken in gardens, parks. Then came the visit to the beach at Camber Sands in East Sussex, where Day persuaded a reluctant Moss to strip off, despite the inclement weather. Fifteen-year-old Kate's unaffected, unselfconscious smile fuelled an iconic photograph. There were many among the session that day, and their appearance in the following July's issue of *The Face* (the Kate–Corinne team-up, bonding over a fondness for bands like Stone Roses, Happy Mondays and Nirvana, had made their debut in its pages in March 1990) showed that the editors had indeed uncovered a star. The shots also established a new fashion genre: by replacing glossy glamour and laboured artifice, Day's photographs of Moss offered something more tangible, gritty, approachable, natural. They revelled in the imperfections, or what might until then have been described as such. (Often forgotten now is that Kate – the face of *The Face* – had appeared on the cover of the May issue, more conventionally photographed by Marc Lebon, wearing a football scarf and holding a football. It was World Cup time. Day had let it be known she was underwhelmed.)

Above and opposite Corinne Day's shots of Kate for *The Face* in 1990 made her name. The cover (above) and unaffected photographs (opposite) marked a generational shift in style.

"THOSE WONDERFUL CHEEKBONES"

"THOSE WONDERFUL CHEEKBONES"

Kate's career was truly off and running now. Galliano took her to his (and her) Paris debut and, to her amazement, she walked the runway on 14 March 1990 with big-name models like Christy Turlington, Linda Evangelista and fellow South Londoner Naomi Campbell. The latter coached, coaxed and advised her, and the pair became long-term friends. Galliano cast Kate as a cross between Lolita and his concept of Anastasia Romanov, the last Grand Duchess of Russia. He told her Anastasia – her character – was fleeing for her life, pursued by wolves. "Go Kate! Go!" he hollered, as she walked out in a complex blue crinoline creation. She went for it, he's recalled, "all guts out". The audience stood in ovation. Now aged 16, Kate loved every second. Celebrating at

Above Already mixing with the hot young Hollywood A-listers, a 16-year-old Kate is flanked by Gwyneth Paltrow and Liv Tyler in June 1990.

"THOSE WONDERFUL CHEEKBONES"

Above Fellow "South London girl" Naomi Campbell swiftly bonded with Kate.

Galliano's office with the others afterwards, she drank so much whisky that she passed out and was sick for a day and a half, missing her flight home. Needless to say, she didn't get to school that week.

"I loved it," she said. "When I met Naomi and Christy they took me under their wing: we had so much fun. The Galliano shows were amazing, like a high – the adrenaline! John tells you your character and you just get so into it because of the energy. And then it was the parties... every night there was something you had to go to. And then you had to be up at six! I mean – it was fun!"

The Corinne Day shots – published in *The Face* under the title "The Third Summer of Love" – had caused a sizeable splash. Day remained intent on usurping the curves, big hair and bigger shoulder-pads of "old" fashion. The intimacy between Kate and her – so visible in the "feather headdress" shot – was the Eighties-become-Nineties version of the "New Look". Kate, for her part, complained to Corinne that she thought some of the images were "gross".

"I see a 16-year-old now," Kate was to tell *Vanity Fair* in 2013, "and to ask her to take her clothes off would feel really weird. But they were like: if you don't do it, we're not going to book you again. So I'd lock myself in the toilet and cry, then come out and do it. I never felt very comfortable about it. There's a lot of boobs. And I hated

Left A more conventionally "sultry" pose for *GQ* magazine, June 1991.

Opposite Channelling classic glamour for *GQ* in 1991. The decade was about to fall at her feet.

my boobs, because I was flat-chested! And I had a big mole on one. That picture of me running down the beach, I'll never forget doing that, because I made the hairdresser, the only man on the shoot, turn his back."

Of course, there was a degree of glamour about this period, but in reality Kate was working for daily rates. Even she is unsure whether she'd technically left school or not. There were spurts of jealousy from her peers in Croydon, inevitably. She had her first "serious" boyfriend, Clark Gregory, three years her senior, who worked at the local branch of Next and bought her earrings and a bottle of peach schnapps for her 16th birthday. They holidayed in New York. The pair survived a driving mishap, escaping with bruises when a speeding Clark hit a stationary car, writing off his own vehicle. Clark was far from the only person to fall for the rising star now. "She'd show me her latest photographs and tell me what she'd done," he's remembered, "but, really, she didn't discuss it that much." The Nineties were about to genuflect at her feet.

KATE MOSS
"PRETTY WILD"

"PRETTY WILD"

MARIO SORRENTI, some say, looked a lot like Clark Gregory.
Yet his career trajectory was more in sync with Kate's. A photographer – and an ex-model – he was the first boyfriend with whom she could mix work and play. He was born in Naples in 1971, and his Italian family moved to America ten years later. And America was somewhere Kate wanted – and had, as yet, failed – to make an impact.

Sorrenti had moved to London when he was 19, admiring other up-and-comers like Corinne Day and Juergen Teller. The "street" fashion magazines were the best "in" for aspiring camera-wielders at the time, with their defiant alternatives to supermodel glitz and their semi-ironic celebration of grime, monochrome, basic lighting and slack poses. When he met Kate, he asked if she wanted to be a model because he'd like to take pictures of her. She explained that she was way ahead of him. He wasn't deterred. "He

Page 34 Sitting pretty: staring out at a nocturnal Nineties.

Left First we take Manhattan: Kate with photographer Mario Sorrenti, her first "power-couple" relationship, 1993.

Above Kate and Mario still on amicable terms at the New York City Ballet Gala in November 1997.

was also modelling at the time," she said. "I was kind of seeing a friend of his, and then his friend went away and he kind of pounced on me. Which is a bit naughty. But I'm glad he did." Sorrenti has recalled that he was crashing on friends' sofas when they met, while Kate "was living with her mother. We just had this amazing time. You know, we were all very young."

This spelled the end for Kate's romance with Clark Gregory. He's mused gallantly, "I think she became lonely (at work) and it was then that she started to really make friends in the modelling world and that we started to clash. Also, I wasn't riding high like her. I was living a normal kind of life. She was the one they wanted to meet." They split in May 1991. Clark has described how they hadn't seen each other for a while "because she had been jetting off to Tunisia and Spain". They drove to a pub in Warlingham for Sunday lunch but couldn't stop arguing. "Afterwards we pulled in at a lay-by and agreed to split." First, he had to drive her home to pack because she was flying off again. There were tears. "We said we'd get back together again and, at the time, I think we both hoped it was true. But then I found someone else, and so did she, and it just never happened."

37

"PRETTY WILD"

Opposite Every photographer worth his salt has shot Kate Moss, and Terry O'Neill was no exception. This image is from 1995.

Below Dour in Dolce & Gabbana, from the mid-1990s.

Strangely, Kate's glamorous – if briefly homeless – new beau was soon staying with Kate in Croydon at her mum's. Linda liked him. "I didn't mind at all when she asked me if he could stay." In typical liberal-Linda fashion, she added, "They just did their thing while I did mine". They were indeed doing their thing, which, often enough, fudging the line between personal and professional, was taking photographs. "Then I went to New York with him," Kate has said, "and met other photographers."

Until now, there had been little indication that Kate could, to use the obligatory verb, "conquer" America. If a model wanted to make it big, that was a necessity. Sarah Doukas knew this only too well. The likes of *The Face* gave you street-cred but not big dollars. In 1991 she despatched Kate to a New York agent, who, reading her height and vital statistics, refused to even meet her. The Brits realized this wasn't going to be a pushover. There was rather more joy when Storm set Kate up with Women Management, run by Paul Rowland. He was keener to take risks, partly because he had no female models on his books as yet (his Men Management was more established). Kate and Mario travelled together, and this time it was her turn to stay with his mother, Francesca, and his siblings. Kate got on well with Francesca and her daughter, Valida.

While Rowland opened New York doors to Moss, Mario and Kate solidified as an item: arguably, this was the first in her chain of glamorous "power-couple" relationships. Sorrenti's photographs had by now landed Kate's brother Nick Moss a place on Storm's books. Within a few months, bigger fish were biting. Sorrenti landed a contract with the magazine *Harper's Bazaar* and was shooting for Calvin Klein. Through early 1992, the couple travelled to Paris, Milan, Berlin. Kate was always booked now, for photo sessions or catwalk shows, and partying to unwind afterwards. She was invited to *Harper's Bazaar*'s offices. The editors were initially sceptical, believing the demographic of *The Face* to be hip but uncommercial, but as Liz Tilberis, then editor-in-chief, has recalled, "The second she walked in (we) knew we were looking at a true beauty: someone whose face and attitude were a personification of the time." They still fretted over her height, but reasoned that Twiggy – the British It Girl of her time – had been short and skinny too. "This girl was so mesmerizing, she was worth a try." The "try" succeeded. The prestigious magazine relaunched in September 1992 with a nine-page feature centring on Patrick Demarchelier's photos of Kate. Next to shots of her in blonde and brunette wigs and startling designs, the text roared: "Wild! Remember a time when genders were bent, rules broken, inhibitions shed and all the best girls were pretty wild?" Just maybe, around here, Kate began to believe her own press. She appeared in the next eight editions of the magazine.

She was soon in *Vogue* too, wearing Dolce & Gabbana. Her hair was styled by a friend from Croydon, James Brown. They grinned at each other, marvelling at how far they'd come so swiftly. Things were snowballing now. A contact at *Harper's Bazaar* was helping Calvin Klein seek out a new model, a

fresh face. Klein's first choice had been – and this is an extraordinary twist of fate when you consider Kate's future love-life – a young French singer and Coco Chanel model, Vanessa Paradis. She declined. Kate was invited to meet Klein in New York. She was advised to show up in jeans. Calvin was transfixed. He was a master of promotion and advertising, but recent shots of young amateurs had seen his commercials dubbed "kiddie-porn" by some critics. Brooke Shields had purred, "Nothing comes between me and my Calvins." Controversy raged; sales rocketed. He now had to find the right balance between iconoclastic and palatable if he wanted his product to cross over to the masses. He thought Kate had just the right degree of edge, of safety-net grunge. She was the new Calvin Klein girl.

"Grunge" was enjoying its moment. Generation X teenagers soundtracked their angst and befuddled despair with Seattle's Nirvana. The young – and those who wanted their wallets – craved a physical representation of their crusade against traditional glamour. They wanted not slick, manufactured beauty but idols with whom they could identify. They wanted women/girls with attitude. Klein had seen the Sorrenti shots of Kate for *Harper's Bazaar* and swooned, "She had this childlike-womanlike thing I hadn't

Left Lending a hand on the catwalk for Marc Jacobs' grunge-inspired collection for Perry Ellis, Spring/Summer 1993.

"PRETTY WILD"

Right Channelling the grunge vibe in pigtails and trainers, Kate cracks a smile in 1993.

seen for a long time. It's a new kind of beauty. Not the big, sporty, superwoman type, but a glamour which is more sensitive, more fragile."

The campaign turbo-boosted Calvin Klein as a brand name. It did just as much for Kate Moss. She signed a lucrative deal: a first sum of £75,000 then a five-year-deal for £2 million. For that she committed to a hundred days' work within that period, plus an exclusive advertising deal that prevented her from promoting other brands (though she could still do magazine shoots and catwalk shows). Her first challenge was to grapple with the future actor Mark Wahlberg, then a hunky heart-throb rapper "Marky Mark", brother of Donnie of boy band New Kids on the Block.

"I'm always taboo-breaking," bragged Klein. "I've done everything I could do in a provocative sense without getting arrested." Kate was cast opposite Wahlberg, his toned muscular frame and "dangerous" macho demeanour seen as the perfect contrast and foil to Kate's perceived frailty and innocence. "Marky" had been in jail as a teenager and was an early exponent of the boxers-flashing trend. He'd been suggested to Klein by the designer's close friend David Geffen, the music mogul, whose label Wahlberg just happened to be signed to. He was content to pocket a cool million from Klein.

In their underwear, naked from the waist up, the pair posed uncomfortably. There was scant chemistry between them. Wahlberg muttered: "Kate is a very nice girl, but, see… everyone is different… she's very thin, very small, and I like a bit of meat – you know what I'm saying?" "We weren't really each other's types," concurred Moss. "He was this young homeboy, really young, and he liked girls with big butts and big tits. I don't really fit into that category." Yet they curved towards each other sufficiently to make the shots work.

"PRETTY WILD"

Above The year 2006 saw Kate re-crowned as the Calvin Klein girl, shown here in a billboard ad for jeans in Soho, New York.

Opposite The original Klein ads from the 1990s rocketed Kate to international fame as a controversy-magnet.

The resulting ads blazed across billboards, buses, magazines, and on MTV (the target demographic) – they were deemed too racy for terrestrial TV. Solo shots of Kate were mostly nude: she looked even younger and skinnier than usual and, again, Klein faced accusations of sexualizing children, of child pornography, of glamorizing anorexia. Women's groups protested. Graffiti appeared scrawled over the posters, adding slogans like "Feed me" and "Give me a cheeseburger". Even *The New York Times* wrote, "Some social critics see an allusion to hard drugs in Moss's dead-eyed, hollow-cheeked look." The "Heroin Chic" controversy had begun. Eventually, no less an eminence than President Bill Clinton was to wade in to the debate, announcing, "You do not need to glamorize addiction to sell clothes. Some fashion-leaders are admitting flat-out that images projected in fashion photos in the last few years have made heroin addiction seem glamorous and sexy and cool. And as some of the people in these images start to die now, it's become obvious that is not true. The glorification of heroin is not creative, it's destructive. It's not beautiful, it is ugly." (In 1997, Mario Sorrenti's brother, Davide, also a photographer, died from a heroin overdose, aged 20.)

If the morbid attraction of Klein's ads put Kate on the brink of global fame, she paid a price. "It was upsetting, absolutely," she sighed. "I was a scapegoat. The media had to put the responsibility on someone, and I was chosen. Just because someone is thin it doesn't mean they're anorexic. No matter how many times I say I'm not anorexic, they don't want to hear it. They're blaming me for a disease I have no control over." Sorrenti voiced his opinion: "I suppose there was a moment when people were taking pictures that could give the impression of glamorizing drugs – but it was very fleeting, and the press made it seem more significant than it was."

Two decades later, Kate told *Vanity Fair*, "I had a nervous breakdown when I had to go and work with Marky Mark and Herb Ritts. It didn't feel like me at all. I felt really bad straddling this buff guy; I didn't like it. I couldn't get out of bed for two weeks. It was just anxiety – nobody takes care of you mentally. There's a massive pressure to do what you have to do. I was really little! But it was work, and I had to do it…"

Probed on "heroin chic", she added, "I had never even taken heroin: it was nothing to do with me at all. And I was never anorexic. I think Corinne loved that Lou Reed song, and that whole look. But I was thin because I was doing shows, working really hard… you'd get back to your B&B and there was no food. Nobody took you out for lunch when I started. Carla Bruni did once; she was really nice."

Sorrenti had been hired by Klein to shoot Kate for his Obsession perfume ads. The couple flew to Jost Van Dyke, a remote island in the British Virgin Islands. The subsequent session was a ground-breaking, landmark shoot: steamy, intimate, sensual. It further changed the landscape of fashion, but rattled their relationship.

Calvin Klein

KATE MOSS
OBSESSION

cK one K

Calvin Klein

a fragrance for a man or a woman

"WHEN WE WENT TO NEW YORK

we were famous within a year," Mario Sorrenti, now married and a father has said. "It was pretty insane. A whole lot of responsibility, and a whole lot of work. We were together for two and a half years, and then went our separate ways. We're still close."

They were extremely close when he – surely with a slightly self-serving eye for his big break – showed Calvin Klein his personal "erotic" photographs of the 18-year-old Kate. Klein had Moss booked for his perfume ads and gushed, "It was perfect for Obsession. His real obsession with her. You can see the love he has for this girl. I said: 'Let's give him a camera and let him shoot his feelings for her.'" Sorrenti probably already had a camera or two. Still, off the pair were packed to Jost Van Dyke, just off St Thomas. Moss acknowledged that this was "very clever". They had been before, holidaying and getting away from it all at the end of 1992. Sorrenti had photographed his inamorata all day and all night, without make-up, without clothes. Now with Klein funding them to explore their obsession and "go again and do something for the perfume", what could possibly go wrong?

Despite the idyllic location and their passion, plenty could. Not with the ad campaign: that was a winner. But their relationship was in trouble. Its very intensity made it challenging to work. As the ads' slogan ran: "Between love and madness lies obsession." They argued and fought in the beach house they'd rented. Moss has recalled hearing Sorrenti honing footage he'd shot, in the next room, shouting, "I love you, Kate, I love you!" He insisted on Kate being naked and without make-up for most of the shots. She's said, "We fought the whole time. Mario was like: 'You have to be naked, man. It's about purity: you have to be pure.' And I was like: 'What's the difference if I have a pair of knickers on?' But at the end of the day, you know, he had the control." Well, some of it. After six days, Klein's VP of advertising, Neil Kraft, was sent to check on the pair. Sorrenti was relatively untried: they were protecting their investment. Kraft brought in hair and make-up people and a director but, ultimately, "we didn't need any of it".

Notwithstanding the fraught atmosphere and friction, the sessions were famously fruitful. Witnessing the results, Klein knew he'd gambled smartly on utilizing the pair's authentic passion. "It's believable. How Mario feels about Kate… people want that reality." The footage Sorrenti had filmed also spawned a commercial, with Moss – clothed, unusually – staring blankly at the lens as he expressed his devotion as a voiceover, accompanied by waves and heartbeats. While critics eulogized the ads, the zealous voiceover took some knocks. "If there is any problem," suggested *Adweek*, "it's with their voices. Kate has a reedy little one, and Mario is allowed too much heavy breathing to say too little ('I love her… I love you Kate… love is a word you can't explain…')" Even Kate didn't disagree. "I think it was a bit much, actually. I didn't

Page 44 Wayward angel: Kate as muse for Galliano, 1993, for the Spring/Summer 1994 collection.

Opposite Obsession session: CK One fragrance ad from 1997.

Below "Between love and madness…" The Obsession ads "represent the new spirit of a Nineties woman".

Opposite New Year's Day 1993: Kate ponders hurtful accusations of "heroin chic", "anorexia" and "being a waif" over a comforting cigarette.

really think about it, it's great he's doing the pictures, but then it came to the voiceover and… 'I love you' and all that…" The head of PR at Calvin Klein declared it *"cinema vérité* for the MTV generation. If you know Kate and Mario's history, you'll have a real connection to these ads… the message goes beyond fragrance." She added, "Kate Moss has a real purity to her beauty. Calvin thinks that she represents the new spirit of a Nineties woman."

The backlash against the campaigns continued. *Esquire* magazine ran a spoof advert captioned Feed the Waifs. It quipped: "For just 39 cents a day, less than the cost of a cup of coffee, you can keep this girl and other supermodels just like her alive." But, as she turned 19, Kate Moss had enough money to keep her in coffee or any other stimulants for the rest of her days. The bright-burning youthful relationship with Mario, however, could not endure. They'd moved into an apartment in Notting Hill together, but now they found separate ones.

Kate's work rate was – even Sarah Doukas has admitted – exhausting. In her own words, Storm were "slave drivers". In one week alone, Moss crossed the Atlantic six times. She took great pride in never saying no. "Why can't I just have fun all the time?" Lasting relationships were bound to be sacrificed, and the pace at which her career had gone through the roof was bewildering and dizzying. When The Waif fell ill at Sorrenti's family home in New York, she was prescribed Valium (but didn't take it).

The year 1993 saw the engines roaring and wheels spinning with even more noise and velocity. There was a German *Vogue* shoot in Marrakesh. She was on the covers of *ID* and *Cosmopolitan* in May of that year, and runway shows took her all over the world. Pretty soon, she was a tax exile conscious of how many days per year she could spend in one place. She was commanding fees in the region of £1,000 an hour or £15,000 a day. In February, she became a limited company. SKATE Enterprises was founded, with her father Peter and Simon Chambers of Storm as directors. (Kate herself didn't become a director until eight years later.) It's an indication of her trust in her father – quieter, business-savvy, less public and less flattered by attention than her mother – that she went to him.

"Clothes sell sex," Kate told *Esquire*, then changed her mind. "Sex sells clothes." March saw *Vogue* coining the style term "London Girl", which ran and ran, with Kate as the focus, and the fashion world celebrating the pallid, bony, straw-haired, almost Dickensian waif-look they obtusely thought of as typically London. "London Style! London Girls! Fashion's New Spirit!" trumpeted the cover. "Half feminine, half tomboy and wholly pretty," elaborated the story. It practically begged to be seen as punkish and rebellious: "These clothes are as far from uptight, power-dressing as it's possible to get." Forget the "international beauty standard set by glowing superwomen, of trying to match the tans, curves and hairdos of Cindy Crawford and Claudia Schiffer, London Girl has come into her own". Kate was styled in homage to Twiggy, her Brit precedent. Through another Sixties survivor, Anita Pallenberg, she met Marianne Faithfull, who was to become a long-term confidante, and one of her gateway friends to the rock and roll world.

Another friend, Corinne Day, was about to re-enter the story. Some thought that Sorrenti's photographs had been toothless imitations of her daring style. (Day, meanwhile, spent most of her time unemployed, despite winning the prestigious Photographe de la Mode prize in 1992. It would be understandable if she felt some envy, although she said, "I think it's beautiful not to have money. It makes you use

your imagination more.") And then, just as Moss's brand and career seemed to be stabilizing on a rewarding plateau, Day's radical new images for (British) *Vogue* of June 1993 tossed her right back into the eye of the storm. Headed "Under Exposure", these eight pages caused a proper palaver, and were slammed as "hideous", "tragic" and, of course, those now-familiar refrains "exploitative" and "irresponsible".

Vogue had probably hoped Day might provide photographs that presented Moss-as-(generic)-model; a safe Waif, perhaps. But editor Anna "Nuclear" Wintour unwittingly unleashed another controversy-explosion. She called Day to New York to meet her, but Day didn't even attend Kate's concurrent catwalk shows – "I'd rather be downtown in the second-hand stores" – and the combo of *Vogue's* traditions and Day's aesthetics was a mismatch. Her subsequent sessions with Kate rattled every convention of fashion photography, actively critiquing established notions of glamour and eroticism. Spurning hair and make-up "style", and photographed in Ann Summers underwear in a barely lit London apartment, Kate looked either sad or depressed (she was, that day); and the final shots showed her yawning, almost sneering. Day herself said, "The photographs looked cheap and tacky – everything *Vogue* was not supposed to be." Before long the fashion world was – borrowing a term from contemporary American literature – describing this

OBSESSION

Opposite left Bubble-wrapped: modelling an inflatable skirt for Karl Lagerfeld in Paris for the Spring/Summer 1993 collection.

Opposite right A cutaway collared dress for Karl Lagerfeld, Spring/Summer 1993.

Right Wearing the trousers: in Yves St Laurent, 1993, the same year she became the "face" of the brand's Opium fragrance.

statement as "dirty realism". Strangely, perhaps bravely, perhaps cunningly, *Vogue* ran the photos. The cover showed Kate looking fresh enough in Chanel. Inside, sensitive readers got a shock.

"Under Exposure" drew a bonfire of bad reviews. *Cosmopolitan* editor Marcelle D'Argy Smith, who only saw "superwaif Kate Moss wearing scruffy see-through knickers, hollow cheeks, blank, staring eyes and bones", ranted: "I believe they can only appeal to the paedophile market. If I had a daughter who looked like that, I'd take her to see a doctor." The photographs worried Judy Sadgrove, too, writing in the *Guardian*. "Are this year's models creating next year's anorexics?" *The Independent*'s Marion Hume thought that the "images resonate with the sexualization of children", while the *New York Daily News* roared that Moss "should be tied down and intravenously fed". Others, slightly more calmly, slammed the pictures as "neither modern nor innovative" and "meaningless".

If they were meaningless, the media-blaze had no trouble locating or inventing meaning, stirring up a debate about art-porn and bulimia and other eating disorders. Feminist author Susan Faludi even reckoned the Moss-waif look was "a man's fantasy of shrinking women down to a manageable size… weak and passive". Of course, Day's intention had been the very opposite. As Sheryl Garratt of *The Face* pointed out, "They are just quite real documentary shots of what Kate is like." One of the shots was displayed in the Victoria & Albert Museum's fashion photography exhibition (alongside work by the likes of Irving Penn, Richard Avedon and Cecil Beaton) just four years later.

If Kate gave an early demonstration of how every controversy ends up boosting her career (she was now a household name), Corinne Day suffered. Exiled by *Vogue* and by Storm, she didn't photograph Kate again for a decade. Kate was given the thankless task of telling her friend her agent had banished her. "I felt hurt by Kate, yes," Day said. "Halfway through the shoot I realized it wasn't fun for her any more. She was no longer my best friend and had become 'A model'." And then Moss soldiered on, ultimately untouched, untouchable. "What do they want me to do?" she snapped. "Get fat? Oh fuck off." She reasoned, "The styling was slaggy in a way. But I love those pictures. And I look my age. Lots of women haven't got big tits, but we still wear lingerie." She declined to enter into the row over anorexia again, saying, "That would just have meant entering into their game. I knew the pictures weren't intended to be what they said they were, and it was really nothing: they just made a fuss about it. It just goes over your head at the end of the day." Fed up at being labelled a "bad influence", she argued, "Women are always going to worry about what they look like. When it was Cindy Crawford who was flavour of the month, everyone wanted to get silicone implants…"

She now rented a big modern apartment in Paris. There were tax-related reasons – the money kept coming in, what with a driven Doukas landing Kate a role in an expensive Vauxhall Corsa TV ad alongside Linda Evangelista, Christy Turlington and Naomi Campbell – but the shift also signalled the demise of the love-nest with Sorrenti. She spoke of his attempts to persuade her to have a baby (at 19) with him. "I'm too young," she remarked pointedly. "We're just having a break," she mumbled at the time, but it was permanent. Kate, not for the last time, was changing her friends, her photographers, her circle of confidantes. Christmas was a disappointing spell back in Croydon: she invited old friends to the pub for a reunion drink but they (including Clark Gregory) failed to show up. She began 1994 drowning her sorrows by partying in New York. And it was there, in January, that she met Johnny Depp.

Opposite Every designer wanted Kate now: the radical Vivienne Westwood clasped her to her bosom in 1993.

KATE MOSS
"HERE'S JOHNNY!"

"HERE'S JOHNNY!"

JOHNNY DEPP is one of the most successful movie stars in history, with the *Pirates of the Caribbean* franchise a monster hit. Between 2009 and 2010 alone, he pocketed $75 million. Sharing the wealth that year, he famously tipped a waiter $4,000 one night. He owns his very own Caribbean island: when he bought it he shrugged, "It just kind of happened." There have been glitches of late: the movie *The Lone Ranger* bombed, losing Disney a fortune, and Johnny separated from Vanessa Paradis after 14 years together. He's hinted he won't keep acting forever, saying, "I can't say that I'd want to be doing this for another ten years."

Earlier in his life he went through his Hollywood rite-of-passage "bad boy" period. "I did every kind of drug there was by 14." He has 31 tattoos and was arrested twice in the Nineties. But then for much of that decade he was half of a much-photographed and gossiped-about couple with one Kate Moss. Legendarily, in 1998, staying at a hotel near Portobello Road in West London, they filled the bath in their suite with the contents of 36 bottles of champagne. A hotel maid, not realizing what it was, made a huge faux pas by pulling the plug and drained the champers away while the pair were out.

The Depp-Moss romance was not just tabloid gold but also, certainly for some time, the great love of Kate's life. In 1999 she was to tell an interviewer for *Dazed & Confused*, "I don't think I've got over my relationship with Johnny." (As it happens, the interviewer was Jefferson Hack, who was to become father to Kate's daughter.)

Kate had had a crush on the actor for a while, with his pictures stuck to the wall of her home. Arriving in New York in the freezing January of 1994, her relationship with Sorrenti over, she attended the black-tie dinner for the Council of Fashion Designers of America (CFDA) Awards, then headed with friends to Café Tabac, a cool joint in the East Village. Johnny Depp dropped in for a coffee. Seeing a mutual friend (a photographer) at her table, he slid over. "It wasn't all that romantic," he said. Yet Kate saw it as little short of an act of God, a sign from the heavens. "I knew from the first moment that we talked that we were going to be together," she said. She spent the night in his hotel room. The next morning, they realized an overnight snowstorm meant they were confined to

Page 54 "This is it," declared Kate of her relationship with Johnny Depp, whom she met in January 1994.

Above Kate models Chanel in 1995.

Opposite Sashaying down the catwalk in Karl Lagerfeld in 1994.

57

"HERE'S JOHNNY!"

quarters together for a few hours more. Neither was complaining. As Kate had with her only the short skirt and impractical shoes of the night before, she arranged for a change of clothes to be couriered over: no mean feat in the weather conditions. Depp wasn't rushing her to leave. "If that hadn't happened," she mused, "I don't know – we may never have phoned each other." The enforced extra time only cemented the bond the pair had felt. She had fallen head over killer heels.

"I was never in love with anyone until I met Kate… I'm crazy about her," said Depp soon after. At this time, he was the wilder child of the two. He loved her accent. They moved in together almost at once, and Kate would spend much time cohabiting with Johnny over the next few years. They "went public" immediately, and in February 1994, Kate was Johnny's date in LA for the premiere of his eight-minute directing debut *Banter*: a salvo against drug abuse. No irony there, then. Just a few months earlier, Depp's friend River Phoenix had died, aged 23, from an overdose at Depp's fashionable nightclub, The Viper Room.

Moss was famous but Depp, whether he liked it or not, was on an altogether higher level of celebrity as the heart-throb star of *Edward Scissorhands* and other movies. The pair's every move was commented on, and their appearance at the premiere – also

Above With Depp, Kate certainly met new people. When Johnny threw a 38th birthday party for fellow actor Mickey Rourke, drinks were taken.

Opposite Flying blind: Moss and Depp at Heathrow airport in 1995.

attended by another Depp ex, model Tatjana Patitz – was described as "very scruffy", even though, despite her leather jacket, Kate had clearly made an effort at glam beyond the "boho". She was infatuated, and eagerly read books enthused about by her beau. The girl who'd been too busy for school now lapped up the literature of Kerouac, Fitzgerald, Capote and Depp's friend-to-be Hunter S. Thompson. When country legend Johnny Cash played The Viper Room, it wasn't long before Kate made her debut in a music video for Cash's "Delia's Gone", as a kind of sepia ghost who comes back to haunt the singer after she's murdered. Such intense passion was par for the course for the blooming of the Moss–Depp affair. Work obligations often separated them but only made their hearts and lusts grow fonder. Depp showered her with gifts, having her hotel rooms filled with daisies (her favourite flower), giving her diamonds to wear when they went to Naomi Campbell's book launch in London together. In April he witnessed her model for the first time at an AIDS benefit at Hollywood's Chinese Theatre. Afterwards, they had a private party at The Viper Room with Campbell and Linda Evangelista.

They rode rollercoasters at California's Magic Mountain. They canoodled on yachts and beaches, from St Barts to St Barthélemy. "I can't believe it," said Kate. "This is it." When they holidayed on Necker Island (owned by Richard Branson), Kate invited her mother along. Many boyfriends may have baulked at this idea but Depp had his own mother's name tattooed on his arm and welcomed Linda. He'd later visit Croydon, happy to stay with Kate at Linda's house. Over their time together, Kate would befriend a range of his cohorts, from Marlon Brando to Iggy Pop. Subsequently, when she found herself at the heart of the Britpop movement in the UK, other odd friendships would evolve, like Depp and Noel Gallagher. *Playboy* declared Johnny and Kate "the prom king and queen of young Hollywood – beautiful, thin chain-smokers with an air of sex and tragedy".

"HERE'S JOHNNY!"

Any tempestuous romance worth its salt isn't all smiles and roses. Depp called her his "little girl"; her child-like lust for life leavened his darker moods, but there were fights and flare-ups too. Depp had alcohol problems then, and the actor, in a drunken fit, trashed a New York hotel room. He was arrested, and made to pay damages, before being bailed. (One can see how Kate acquired a high-tolerance level for outlandish behaviour in boyfriends long before Pete Doherty.) Depp wasn't yet the blockbuster-multiplex darling: he was "edgy", "dangerous".

This particular tantrum occurred at the Mark Hotel on the Upper East Side in September '94. The noise coming from Johnny and Kate's presidential suite – furniture flying around and bouncing off the walls – suggested a serious fracas, something more than a lovers' tiff. Kate was in tears as the manager threw them out, and an especially dishevelled Depp was handcuffed and taken away by the police. She found sanctuary at Naomi Campbell's apartment. He was charged with "causing mischievous damage" and spent 48 hours in jail. At least he had the grace to acknowledge that this was a turning-point in his life. Hilariously, he possibly has Roger Daltrey of The Who to thank. For it was Daltrey, singer of lines like "people try to put us down", who'd complained about the

60

Opposite above Johnny interviews his hero, author Hunter S. Thompson, at his Viper Room club in LA, in 1996. Depp would go on to play Thompson in the 1998 film *Fear and Loathing in Las Vegas*.

Opposite below The Viper Room also hosted Johnny's surprise 21st birthday party for Kate in January 1995, which she called the most glamorous night of her life.

Right Getting serious: stoic expressions in London, 1995.

"HERE'S JOHNNY!"

racket to the hotel management. Roger, from the next suite, found Depp's hotel-trashing disappointing in more ways than one. "On a scale of one to ten, I'd give him a one," he commented. "It took him so bloody long. The Who would have done it in one minute flat." Later, Depp claimed he was merely chasing a massive cockroach around.

And there were confusing signals among the loved-up bliss. "We're just having fun, a lot of it," remarked Depp at one stage. When Kate signed in at one hotel as "Kate Moss Depp", he apparently muttered, "Quit that." Years later, he sighed, "Kate is somebody I care about deeply, but I wasn't very good for her at the time. She's better off without me." Contrastingly, he'd do things like proudly show presents he'd bought for his "little Kate" to interviewers who were asking him about his latest films. And for her 21st birthday party, on 14 January 1995 (two days early as a surprise), he pulled out all the stops. Asked a decade later if she could pinpoint the most glamorous night of her more-than-averagely glamorous life, Kate plumped instantly for this one.

Like any surprise party, it had both positive and negative twists within its narrative. Kate had spent the day wondering why her usually hyperactive phone hadn't rung much. She knew that Depp, with whom she'd recently holidayed in Aspen, was taking her out to dinner that night and had told her to wear "something cool", but wasn't expecting him to take one look at the red satin floor-length sheath dress she chose and whip out a pair of scissors. He chopped the hem into jagged V-shapes. So far, so Johnny,

she reasoned. Then he said he needed to drop in at The Viper on the way; she might as well come in with him for a quick drink. Walking in, she was stunned to see all of her favourite people assembled there. Galliano, with a white dress as her present. The model A-list of Campbell, Evangelista, Turlington, Elle McPherson and Helena Christensen with boyfriend Michael Hutchence, who was later to sing "Gloria" onstage with Johnny in accompaniment. Sarah Doukas brought a huge Union Jack cake, out of which leapt Kate's Croydon hairdresser friend James Brown. Kate was naturally thrown, but soon regrouped and gave Johnny the most passionate kiss, delighted. Gloria Gaynor sang "I Will Survive" (along with a rendition of "Happy Birthday"); Aretha Franklin and Thelma Houston joined in. Johnny gave Kate another dress, but not just any dress: it was a black-sequinned replica of the one Julie Christie wore in *Shampoo*, a film they'd watched and enjoyed together. On top of this, he'd found her a rare edition of *Alice in Wonderland*, of which only 200 copies were ever printed, with lithographs by Salvador Dalí. Kate felt, to her glee, very much like Alice that night.

If only Jason Donovan hadn't collapsed on the floor through overuse of cocaine, the night would have been perfect. Jetlagged, overexcited at being invited to such a swell party by acquaintances he vaguely knew, the Aussie singer-actor – successful at the time, less so now – had been enjoying himself rather too well. Before the ambulance arrived and took him to Cedars-Sinai hospital, Michael Hutchence checked to make sure he hadn't any drugs in his pockets: "It wouldn't be cool if anything was found on you by the medics." Donovan discharged himself a few hours later, with the doctors simply advising him to "lay off the drugs". He was deeply embarrassed and felt guilty for spoiling the party, but when he went to apologize to his hosts – whose "after-party" was busily carrying on at a hotel, as it would continue to do for a few more days and nights, through Kate's actual birthday and beyond – Depp sympathetically told him just to get some sleep and "take it easy in future". Depp and, indeed, Kate inhabited a world where they had seen much worse.

For Kate, the night represented more than hedonism: it felt to her like she had arrived at another level, where her life could be about more than modelling. And there can be little doubt that she thought Depp was "the one". Their mansion in Los Angeles bore a large D and M on its electronic gates. "I could see myself being married to Kate for 50 years," Depp had gushed. He, however, ten years her senior, had already been married at 20 (to make-up artist Lori Anne Allison, who had encouraged him to take up acting), as well as engaged to, in turn, Sherilyn Fenn (of *Twin Peaks* fame), Jennifer Grey (of *Dirty Dancing*) and *Edward Scissorhands* co-lead Winona Ryder (as evidenced by the "Winona Forever" tattoo that he later amended to read "Wino Forever"). Despite his chasing-the-night tendencies, he was within a year or two of again settling down, and parenthood. But not with "Kate Moss Depp". Their final split in 1998 was to send her reeling into rehab.

For now, though, they were as high as the balloons that filled The Viper on her 21st birthday. A book of images of Kate, some previously unpublished – simply called *Kate* – came out in April 1995. Kate deemed it "slightly premature", but Storm initiated it and Kate managed to make sense of it by claiming it wasn't about her and dedicating it to "all of the people I have been lucky enough to work with". Both her parents and her brother attended the London launch, laughing off the news that t-shirts bearing the logo "Kate Moss – Smack Head" (nothing to do with her) had gone on sale in New York. Peter Moss pointed out how hard his daughter had worked. (Following his advice, she

Above and right The Depp–Moss Los Angeles residence, hence the initials "D" and "M" on the gates, photographed in 1995. Despite their domestic bliss, the actor didn't like Kate using the name "Kate Moss Depp".

Opposite Kate at a book signing in April 1995 for the "slightly premature" tome *Kate*, initiated by Storm.

Right Kate is the picture of elegance on the Givenchy catwalk in 1995.

now bought a house in Shepherd's Bush, west London. A few years later, she sold it on at a large profit, because she lived mainly in New York and was hardly spending any time there.) Kate gave rare TV interviews, in which she made it clear how much she loathed being called "The Waif". When the book emerged in the States a few months on, Johnny accompanied her to the launch at the hipper-than-hip Danziger Gallery in Manhattan. He rather stole the focus by loudly protesting against nuclear testing, but Kate joined in eagerly.

It may surprise some that when asked some years later who was the sexiest man she had ever met, Kate didn't answer "Johnny Depp". She replied, "Frank Sinatra." On 19 November 1995, she was among the few hundred invited guests at the Sinatra 80th birthday celebrations at LA's Shrine Auditorium. Tributes to Ol' Blue Eyes were sung by Bruce Springsteen, Bob Dylan (whom Kate met that night) and others. Not shy, Kate, a fan of the king of crooners, went up to Sinatra and introduced herself. She was greeted with a kiss. "But not with tongues," she clarified. Then he offered her a drag on his cigarette. Eulogizing his matchless cool, Kate added, "I don't think he recognized me: I think he just fancied me."

She and Depp returned to Aspen, Colorado for a second consecutive Christmas-time holiday among the snowy mountains, with Linda and Nick Moss joining them. The four drank and played board games and charades, at which the actor was in his element. Kate's skiing was improving.

Kate's 22nd birthday was spent in London, with Johnny hiring Julie's Restaurant in Holland Park for a dinner with – again – a surprise selection of friends and family. It may not have been as glamorous as her 21st in LA, but she was more than happy. The couple were spending more time in London, though it wasn't home at this point. They championed the War Child charity, appearing on *The Big Breakfast* on Channel 4 together. (Depp woke up late so they only made the last five minutes of the show.)

After Kate had appeared at the year's London, Paris and Milan fashion weeks, she caused a minor sensation in March 1996 by failing to show up for the New York runways. She later claimed she felt on the verge of a breakdown and needed to get out of the Big Apple. To many in the industry, it seemed as if The Waif had acquired a chunky ego problem. She was accused of a lack of professionalism and a surplus of arrogance. And where was she? In Chicago with Depp, watching John Malkovich in a play, *The Libertine*, the film of which – produced by Malkovich – Johnny was to star in eight years later.

Upon her return, all was swiftly forgiven and she got back in the saddle for work. Just as fashion was starting to tire of the first wave of the "waif" look – things move quickly in that world – the romance with Johnny had cranked her fame up another few gears. She now rented her own apartment in New York. Depp was filming there for three months, and moved in to her place. Continuing the charity ventures, she and Naomi Campbell hosted a party for Cancer Research: its theme was "Las Vegas".

To one interviewer, prying about their relationship, Depp said, "My relationship with my girl isn't something I'm going to discuss. Whether Kate and me are together or not isn't going to save anybody's life. It's nobody's business but mine or hers." He spoke of old-fashioned romanticism. On another occasion, he said that Kate was "the closest thing a human being can get to a cat. She likes Abba and Big Macs and she can make me laugh like no one else can, and when she walks in a room I see her face and she's like my angel. She's so beautiful it amazes me." Kate, meanwhile, was saying,

"HERE'S JOHNNY!"

Depp starred in the film adaptation of Hunter S. Thompson's *Fear and Loathing in Las Vegas* with Benicio Del Toro (far right). Kate accompanied Johnny to its 1998 Cannes screening, shown here with the film's director Terry Gilliam and his wife Maggie.

Opposite Moody blue: Kate on the Blumarine catwalk in the mid-1990s.

Right Preparations backstage during Paris Fashion Week, 1997.

"He's really wild, but in a nice way. I don't want to tame him… he's complicated, but I like that. He's always surprising me. There has to be some mystery." Yet, for all the love and adoration, the couple began to spend more and more time apart as a result of work and the travel it necessitated. His unpredictability and her intellectual naivety were forces of both attraction and irritation for each other. They would separate, then each time find themselves desperate to reunite. Eventually, to Kate's dismay, she found herself being edged away as he threw himself into his work, and the passion cooled down. She carried a hipflask full of vodka from assignment to assignment.

"HERE'S JOHNNY!"

Right Supermodel Kate Moss models clothes from the FrostFrench range designed by actress Sadie Frost and her design partner Jemima French on stage at the Duke of York's Theatre in London as part of London Fashion Week, 1997.

Opposite Stella Artful: steely gaze in Stella McCartney for Chloé, Spring/Summer 1998, the designer's debut for the french fashion house. Kate had previously modelled for free for Stella's Central St Martin graduation collection show in 1995, along with fellow friends and supermodels Naomi Campbell and Yasmin Le Bon.

KATE MOSS
"EXCESSIVE PARTYING"

"EXCESSIVE PARTYING"

Page 72 Kate partied hard to get over Johnny Depp. At Rolling Stone Ronnie Wood's 50th birthday bash, Jo Wood teaches her how to handle a gun.

Right Every day's a holiday: in Spain, in 1998, with new friend Meg Mathews.

Far right On the island of Mustique in 1996, with Depp, Mathews and Noel Gallagher. Behind closed doors, the atmosphere was "strained".

"DISTANCE IS very difficult when you're trying to maintain a relationship, and you're thousands of miles apart for a lot of the time," Johnny Depp informed the *New York Daily News* in May 1998. "I was a horrific pain in the ass to live with. I can be a total moron at times. I let my work get in the way, which made me difficult to get along with." When he and Kate finally split, he cried for a week, he said. Kate hoped it was just another temporary separation, but as it sank in that they were truly over, she span into a spell of drink and drug abuse, which culminated in her entering rehab in November that year. "Excessive partying", "exhaustion" and "depression" were blamed.

Years later, she said, "I was in love with him and haven't been in love with anyone since." It was another seven years before she met up with Pete Doherty. "It was an intense relationship for four years and for a while there it seemed as if it wasn't real. But it was." Especially galling for her was that Johnny, who'd been engaged five times before, had never seemed committed to settling down with her, but all too soon he was in a full-blown relationship with Vanessa Paradis, with whom he promptly had two children.

Many commented that the French model-actress-singer strongly resembled Kate, who had owed her big break with the Calvin Klein campaign to Paradis turning it down. On another occasion, Depp made a telling, tangential observation: "If you're in a room, you can explore that place completely. You feel the texture of the walls, and you can smell the room without smelling it, and you learn everything about it. Then there comes a time when you say: OK, I've learned it, so I have to go somewhere else now, somehow." Again, he blamed work. And hedonism. "I was working constantly, or getting fucked up: trying to hide from whatever feelings or weirdness might have been inside me. I was trying to numb it by getting loaded or whatever… postponing the inevitable."

Kate, too, continued to work hard, though she noted, "The constant working and partying and travelling can catch up with you." In June 1996, she and Johnny had holidayed in Mustique with new Brit-pack friends Noel Gallagher (Oasis guitarist) and his wife Meg Matthews. Gallagher has recounted that the atmosphere was strained, with the men focusing on writing projects while the women got drunk. Depp's project, *The Brave*, may well have been the straw that broke the back of the Depp-Moss dream pair.

"EXCESSIVE PARTYING"

He was writing the screenplay and would star in and direct the film. The bleak story of poverty – nothing could be further from celebrities in Mustique – meant a lot to him: it tapped into his part-Cherokee lineage and didn't shy away from a heart of darkness. The two couples' return to England and the Sex Pistols' reunion show at Finsbury Park perhaps took his mind off it for a time, but when he briefly moved into Kate's New York apartment again, a spokesperson plainly stated, "They are not engaged. He is still keeping his LA residence." In 1997, he was telling *Vanity Fair*, "It's still fun – she makes me laugh," but when the couple flew to Cannes in May for the premiere of *The Brave*, in which Depp's hero Marlon Brando also appeared ("he did it for nothing"), they stayed in separate villas. The film got harsh reviews. Depp was distraught. "It was the most difficult thing I've ever done and I was an idiot to attempt it." He bounced straight into a film about another friend-hero, playing the Hunter S. Thompson role in Terry Gilliam's *Fear and Loathing in Las Vegas*. Kate felt increasingly neglected. The *Sun* newspaper crowed, "They got on each other's nerves." The press linked Kate with "consummate womanizer" Tarka Cordell, son of record producer Denny Cordell. Depp, however, said, "I have been so stupid because we had so much going for us. I'm the one who has to take responsibility for what happened… I should never have got so worked up over what people had to say about my work. When I get home, I should try to leave that stuff behind. I couldn't do that…" Yet he was also maturing, and now more

"EXCESSIVE PARTYING"

Below The 1997 Cannes Film Festival: Kate's romance with Johnny was coming to an end.

Opposite Kate threw herself into the emergent Britpop scene: cigarettes and alcohol with Oasis' Noel Gallagher at a Steve Coogan after-show party in 1998.

Above Kate with Gallagher, Meg Mathews and Lisa Walker at Sound Republic in 1998.

Opposite Taking the veil? Kate with Gianni Versace as his Paris Fashion Week show climaxes, July 1995. Gianni's death in 1997 profoundly affected Kate.

interested in his work than parties, unlike Kate. Filming *The Ninth Gate* for Roman Polanski in Paris, he met Paradis, who had conquered not just the world of modelling (as the face of Chanel) but was winning acting awards. Soon they were sharing an apartment in Montmartre. A few months later, she was pregnant.

Even in 2012, a happily married mother, Kate was confiding to *Vanity Fair* that she'd never felt as she had with Depp in her early twenties. "There's nobody that's ever really been able to take care of me," she said. "Johnny did for a bit. I believed what he said. Like, if I said 'What do I do?', he'd tell me. And that's what I missed when I left. I really lost that gauge of somebody I could trust."

"Nightmare," she sighed. "Years and years of crying. Oh, the tears!" She was to find solace – or at least distraction – in her homeland, involving herself with the celebrity party scene in London, just as the "Britpop" movement boomed, and becoming a poster-girl pivot at the eye of its shallow whirlwind. She was soon effectively Queen Bee of what became labelled the Primrose Hill set, friends with the Gallagher clique – she had considered Oasis' Knebworth gig of 1996 as "just the best thing ever" – and other "Cool Britannia" Union Jack-waving musicians and hangers-on.

She had a lot to drink to forget. The death of Marco Sorrenti's brother Davide and the shooting of Gianni Versace in 1997 had also affected her. "I am stunned and lost for words," read her statement on the latter, though she sent personal messages to Versace's sister Donatella, who took over as the head of the Versace empire, and, of course, continued to book her. Work prevented Moss from attending the memorial service: she was now with three agencies: Storm, New York's Women Management and Milan's Marilyn. She did attend a gala dinner in Versace's honour in December, at the Metropolitan Museum of Art in New York, with friend Marianne Faithfull. They partied afterwards with Donatella, Cher and Rupert Everett.

When the era's curious concept of the new Marilyn Monroe, Princess Diana, died, Elton John's reworking of "Candle in the Wind" played in almost every British household. The video for its B-side (technically a double A-side), "Something in the Way You Look Tonight", featured Moss amid a group of dancers and models looking healthy and tanned. Turbulent times returned as her father Peter told her he was having a baby with his new Norwegian partner, Inger. Attempting to assimilate all this information and emotion, Kate surrounded herself with a growing group of female friends. Celebrities and quasi-celebrities who lined up to be her best Cool Britannia party gal-pal included Meg Matthews, Sadie Frost, Jade Jagger, Davinia Murphy, Patsy Kensit, Anna Friel and Pearl Lowe. "Moss's Posse" was a dream for the tabloids, who sucked their cheeks in and ran with stories of orgies, wife-swapping and, of course, drink and drugs.

There were yacht trips off St Tropez with the extended Gallagher clan, and Ronnie Wood's 50th birthday bash, at which Kate wore Daisy Duke hotpants, catching the eye of Jesse, son of The Rolling Stones rocker. Ronnie declared Kate his favourite DJ: "When you're at her place she blows you with her musical taste. It goes from Sinatra to Mozart to The Stones, but it's always incredible. She has exquisite taste."

It was with longer-established friends that she rocked through the early stages of 1998, sensing her time with Depp was fading out. Almost as a swansong, a last hurrah, she spent her 24th birthday with him in New York, watching The Rolling Stones play at Madison Square Garden, then propelling the after-party at Wood's hotel suite. Peter Moss's new daughter Charlotte, Kate's half-sister, was born on 9 January. In February, the Moss rollercoaster roared into uncharted territory.

"EXCESSIVE PARTYING"

Above Burn rubber on me: Kate (centre) and five friends model Versace's rubber skirts, Milan, 1995. Versace was instrumental in helping to launch the Nineties "supermodel".

Opposite Free with Nelson Mandela: Kate and Naomi Campbell meet Mandela at a 1998 charity event in Cape Town, South Africa. Away from the cameras, the models' behaviour was reportedly less than wholesome.

Kate, Naomi Campbell and Christy Turlington flew to Cape Town, South Africa, to appear in a Versace charity fashion show supporting Nelson Mandela's Children's Fund. With Mia Farrow, they presented the president of four years with a gaudy Versace shirt. So far, so run-of-the-mill for the fashion world. But behind the scenes, according to some newspaper reports years later citing Storm representative Gavin Maselle, Kate and friends were indulging in cocaine use with every bit as much gusto as they were alleged to be doing back in Primrose Hill. There were stories that vast amounts of drugs were arriving at Naomi's room and that the models' grins may not have been solely down to meeting a modern-day saint. "Kate has been addicted for years," Maselle told the *Sun*. "She was insatiable. I just couldn't believe what I was seeing. We were there at Mandela's house… and Kate was doing coke in the toilet…"

Unabashed, Kate and Naomi decided their status as global style icons could be cashed in yet further afield. In Cuba, while on a shoot for *Harper's Bazaar*, they announced that they'd just met Mandela and that they'd now like to meet controversial Cuban dictator Fidel Castro. After an envoy had checked them out (with Castro secretly watching), the man himself met them for tea for 90 minutes, describing their time together as "very spiritual". Kate recalled that he saluted them as he left. "That, and the thrill of meeting him… (had me) screaming all the way down the elevator, all the way to

"EXCESSIVE PARTYING"

"EXCESSIVE PARTYING"

the car, and all the way back to the hotel." Campbell later added rather grandly, "He knew that I was the first black woman to appear on the cover of *Vogue* and that Kate started the revolution of the little models, so I suppose we were both revolutionaries in his eyes." The United States government was less impressed, fining *Harper's Bazaar* for sending the models to Cuba and thus "trading with the enemy".

Although Kate's hedonism appeared frenetically cheerful on the surface, she was avoiding facing up to her distress over Depp. At the Cannes Film Festival, where the actor was asserting there was "no going back", she was removed from her hotel at 5 a.m. for excessive noise. "They asked me not to wear a bikini around the hotel. Excusez-moi!" she pouted sarcastically. The press spoke of "freefall", of countless "dates". She was referred to as the new Edie Sedgwick. Yet as a counter to all this, she was raking in around £15 million a year from contracts with Dior, Versace, Calvin Klein, L'Oréal and Cerutti 1881. In a TV ad for the mobile phone company, she chose "Elvis" as the person she'd "most like to have a One2One with". She bought herself a house in St John's Wood, off Abbey Road, and her mother a house in Surrey, as well as helping to fund her father's new travel company.

After a rebound fling with Jason Lake, son of the actress Diana Dors, in Ibiza – "I was living it fast (that summer)" Kate has said – and a very public clinch with actress Anna Friel, she took off on a trekking week in India with Anita Pallenberg, seeking enlightenment. If it came, it didn't stick, as when she learned in November of Vanessa Paradis' pregnancy, she finally accepted that she was in emotional and physical trouble. She couldn't recall one occasion in the past decade when she'd walked a catwalk sober or without a hangover. She spent the end of 1998 in rehab at The Priory in Roehampton, south-west London. She'd planned to stay for two weeks. She stayed for five. "I was a bit all over the place," she said.

"EXCESSIVE PARTYING"

Opposite Kate with Jade Jagger during London Fashion Week in September 1997. The pair were to fall out fiercely over a man.

Left Touch Wood: Kate sits between Ronnie and his wife Jo at the wedding of Keith Richards' daughter Angela in August 1998. Kate romanced Ronnie's son Jesse.

KATE MOSS
DAZED & CONFUSED

Page 84 Zinging in Zara. Kate fronted the Autumn/Winter 2003 collection for the Spanish retailer's catalogue.

Right At Kate's 25th birthday party in Paris, 1999, host Donatella Versace gets maternal.

Opposite Steering straight: Kate with (from left to right) Sadie Frost, Jodie Kidd and Sophie Anderton, at the 1999 Earls Court Motor Show.

"KATE'S BURNED OUT," said Storm diplomatically.
"She wanted to re-evaluate her life, and so she put herself in a situation where she's able to do that."

At The Priory, Kate sat quietly, thinking things through. She reflected: "I'd get away with it, but I wasn't completely there. I was in denial for a long time. I was beginning to be not very happy. It just got out of control really. I wasn't clear-headed; I couldn't think properly because I was always hungover. So I didn't really know what was going on – it wasn't real any more."

In rehab, she tried to work out how her life had got so crazy. Her parents' divorce was pilloried by the press, who also mumbled of her heroin addiction, but years of fashion-world decadence had obviously also taken a toll. Anyway, she admitted, "modelling just speeded things up", and she would "probably have got there in the end, whatever". Kate liked The Priory, comparing it to "boarding school". A calm, placid routine served her well (despite a fire in her room, blamed on meditation candles). She changed her mobile phone number. She said she didn't feel like a drink once, and she read C.S. Lewis's *The Chronicles of Narnia*, sent to her by Marianne Faithfull. "This was the best thing I've done for ages," she stated. "I needed to ask myself: what's going on? What do I want?"

On returning home to Melina Place in St John's Wood, all alcohol-based temptation was removed, and the house was exorcised. Twice. She was soon back at work, shooting a Versace set-up with Steven Meisel in New York, taking on nothing stronger than coffee

DAZED & CONFUSED

Right Kate steps out with new boyfriend *Dazed & Confused* editor Jefferson Hack (who was to father her child) and a new haircut at the Chloé show, Paris Fashion Week, 2001.

and cigarettes. She spent Christmas at her mum's with her new friend Twiggy Ramirez, bass player for Marilyn Manson. Linda Moss gave Kate a puppy, which she named Sid, after Sid Vicious. Kate then spent New Year in Dublin with Marianne Faithfull, before holidaying in Marrakesh. She spoke of wanting to break into acting, in something more challenging than music videos. Her new-found quiet life was already gathering volume. She was 25 years old, and temptation was distinctly reluctant to retire just yet. Her return to the catwalk at Donatella Versace's Paris show in January induced a spontaneous ovation. Donatella threw her a "comeback" birthday party, giving her diamonds and rubies but, at three in the morning, a sober Kate went home with her mum.

Later, in 1999, she went out with Antony Langdon of the band Spacehog. A holiday in Ibiza saw him proposing, but this turned out to be another of Kate's passionate but short-lived romances, and it tailed off when they were back in New York. There was

an affair with Jesse Wood (Ronnie's son), which was far from abstinent, and reports of intimate nights with actor Rhys Ifans and Elastica drummer Justin Welch. She posed topless for artists Jake and Dinos Chapman. For all these adventures, friends opined that she was still feeling that no man could live up to Johnny Depp. There was another bump in the road when Calvin Klein, after six years, dropped her as their "face", replacing her with an 18-year-old Russian. Such clinical manoeuvres are, of course, inevitable, but she must have felt a pang. "No one can replace Kate," said Klein, gallantly.

It wasn't as if Kate was struggling for work, rehab "scandal" or otherwise. Burberry bought in to the Moss brand (signing her and Madonna) to reboot its cool. She made some attempts to reinvent herself as a more artistically inclined entity rather than just a legendary "caner" who could match Keith Richards drink for drink. She was giving more interviews than usual too, sighing, "I was drinking when I was 14 in Croydon… I don't think it's anything to do with my work" and, of Depp, "We grew apart… now he's got his life and I've got mine." She also came out with, "I'm broody… I love kids. If I haven't met Mr Right in a few years, I'm going to do it anyway, definitely."

One interview, in February 1999, was to lead to a story that ran and ran (and certainly did something about that broodiness). The net result – three years later – was Kate's daughter, Lila Grace.

As the year moved into summer, Kate took time out from modelling, holidaying in Ibiza again with Stella McCartney and Meg Matthews, and making noises to the effect

Below Burberry signed Kate in 1999, helping to rejuvenate the brand, and continued to work with her over the years. This ad from 2005 was photographed by Mario Testino.

Above New flame: Red-head Kate with Dan Macmillan, great-grandson of British Prime Minister Harold Macmillan, after a Cher gig at London nightclub Heaven. Not Jade Jagger's favourite photograph.

that she'd quit the business, although such conviction was fleeting. "I wasn't happy with the way my life was going. I quit because I thought: I hate it. It's mind-numbing, repeating yourself like Groundhog Day. I didn't want to have to say 'I'm a model' ever again." Her long hair became a blonde bob, then an ultra-short "Mia Farrow-Jean Seberg-style" crop. The spell at The Priory had redirected her objectives, but a serious new relationship played an influential part – she was soon stepping out with the interviewer she'd told of her broodiness and search for Mr Right, *Dazed & Confused* magazine editor Jefferson Hack.

The 28-year-old former public schoolboy and art student had founded the uber-trendy publication with fast-rising photographer Rankin with a loan from Rankin's father. The magazine caught the zeitgeist of Britpop and the Young British Artists boom, opening club nights and an art gallery. His interview for the February issue, after Rankin had shot Kate in black lingerie, included the question, "There's been a lot of different men mentioned in your life recently, but no permanent relationship. Is there no one out there good enough for you?" She spoke of Johnny Depp, cooing, "I don't think I've completely got over my relationship (with him). It's hard for me to think about being in love with anyone else. It was so intense for four years and it's still quite strange." She also told Hack, "It's hard to say no... I've never said no to having a good time, to anything." Yet she moaned that she didn't even have a crush on anyone. Hack wrote that she was "gregarious and gorgeous", but his pining was not requited for some time. Kate promptly started her affair with Antony Langdon. Vanessa Paradis gave birth to Depp's daughter Lily-Rose in May, and he told interviewers, "Anything I've done up to this day was kind of an illusion. Existing without living," which must have thrilled Kate. As friends like Matthews and Samantha Morton got pregnant, she began to see signals all around. "Everyone seems to be having babies at the moment," she remarked.

Of course, the partying still hadn't stopped. There was another high-profile fling with "millionaire socialite" Dan Macmillan, a model himself. The catch was that he was dating another Rolling Stones offspring, Jade Jagger, who had hoped to marry him, at the time. Jewellery designer Jade, who had considered Kate a close friend, was furious. She sent Kate a necklace spelling out the word "Slag". The two fell out and avoided each other for years. The "new, reformed" post-rehab Kate continued to behave less than impeccably. She arrived at a party at the Chelsea house of Canadian rock-star-cum-photographer Bryan Adams wearing a raincoat "and not much else". For a while, everything Adams did, he did it for her, but by now she figured she was going to be faithful to Jefferson Hack. They were first seen in public as a pair at the January 2001 premiere of her friend Jude Law's film *Enemy at the Gates*, at the Berlin Film Festival.

In Kate's relatively unpractised eyes, Hack offered intelligence, an education in the arts. She aspired to be as sophisticated as Vanessa Paradis. She hung out with the hyped-up art crowd, with Tracey Emin, the Chapmans and Sam Taylor-Wood using her as a model-muse. *Vogue*, in recognition of her sky-high "iconic" status, commissioned a series of Moss projects. Emin produced a sketchy felt-tip nude drawing; the Chapmans scrawled cartoons over her dashed-off self-portrait. Gary Hume projected sketches of her onto her body and took photographs. Sarah Morris delivered a colourful Pop Art Kate in a swimsuit, while Taylor-Wood represented Kate as a veiled, crying Madonna in a church. Marc Quinn cleverly cast an ice sculpture of her, which would subsequently melt. Kate was naturally hugely flattered by her transformation from working model to national artistic treasure: it definitely boosted her morale as to her purpose in life.

Right From Purley to pearls: Kate as the face of Chanel's Coco Mademoiselle, in a magazine ad from 2005.

However *The Independent* found the nepotism and cliques irritating, seething, "Fashion and Brit-Art are simply in the same business, and that business is fame." By the autumn, to the relief of Storm, their cash-cow Kate was back on the catwalk.

The agency knew it had to produce some new tricks to keep her interested. Sarah Doukas purred that "… she's gone to the next step. She looks more grown-up, more sophisticated, more knowing, more together." She landed roles as the new face of the perfume Mademoiselle Chanel and shot more ads for Gucci and Burberry. Her connection to the Brit-boom was a plus as she starred as the face of Rimmel cosmetics, getting "the London look" and a handy £2 million to boot.

Someone wasn't looking in London in November when, with Moss in the States, thieves burgled her St John's Wood home. What police labelled "a highly professional

DAZED & CONFUSED

Opposite Kate with her Model of the Year trophy, presented at the British Fashion Awards in 2001.

Above left and right Strawberry blonde: magazine ads for the British cosmetics company Rimmel from 2008 (left) and 2005 (right). Kate has been the "face" of the brand since 2001.

job" saw jewellery and other items worth around £300,000 taken. Kate was most stung by the loss of a necklace, the first present that Depp had given her as they became lovers. Terrified, she refused to return to England and the house until a new alarm/surveillance system was up and running. Still she tried to branch out, to be "more than just a model". A Primal Scream video wasn't going to suffice. She took an actual acting role as Maid Marian in the TV comedy special *Blackadder Back and Forth*. She wasn't required to do much bar sparkle flirtatiously, and had no real chance to test her comic-acting chops against Rowan Atkinson, Tony Robinson and company.

As the twenty-first century got into gear, she craved a significant gear-change herself. Model of the Year in 2001, she reunited with exiled old friend Corinne Day for a shoot in May, in Blackpool. It wasn't a great experience for the photographer who'd given Moss her first leg-up. "I didn't want to be there," she said. "Our relationship, I knew, was over." As she tried to re-create their "grunge" heyday look, the atmosphere was tense. "I just looked at Kate's face and it said it all. She was quite horrified... she'd definitely gone into another world." Maybe Kate's mind wasn't fixated on glamour, however. As she enjoyed her new half-sister, she told friends with increasing regularity that she was ready to have a baby. To her, the decision represented a shot at stability and responsibility and a meaning among all the madness.

She and Hack had become close and were spending more and more time together. For Kate it made a refreshing change from her typical whirlwind, all-or-nothing passion binges. There was much surprise from her circle of friends and from the media, with remarks of the "What does she see in him?" variety. Yet if Hack wasn't the heartthrob-type she was usually linked with, that too, in her mind, made the relationship serious

Left Forever young: Kate strolls down London's Kings Road with Sixties icons Marianne Faithfull (centre) and Anita Pallenberg (right) in 2002.

Opposite Revered artist Lucian Freud's 2002 oil-on-canvas portrait of a pregnant Kate Moss. Months in the making, it eventually sold for around £4 million.

and gave it a potential future and longevity. In March 2002 they were dining with his parents with something to celebrate. Kate was expecting.

Her own parents were delighted. Peter Moss commented, "It is something she really wanted. Kate called to tell me she was going to be making an announcement. She sees getting pregnant as one of the best things that has ever happened to her." Some acquaintances were less kind, nicknaming Jefferson Hack "the sperm-donor". The couple rented an Oxfordshire country cottage as a retreat. Kate claimed to enjoy putting on weight, but, to nobody's real surprise, failed to give up drinking and smoking. She boozily duetted with Primal Scream frontman Bobby Gillespie on a cover of Lee Hazelwood and Nancy Sinatra's "Some Velvet Morning". The press, of course, fuelled rumours about this unlikely pair.

She did find a way to do meaningful work while pregnant. Nurturing her new "art symbol" status, she posed for a portrait by the revered Lucian Freud. (In 2005, a picture from these sittings sold for around £4 million at Christie's). Having read of her admiration for his work, the septuagenarian Freud – an infamous womanizer – invited Moss to lunch (before her pregnancy was discovered) and a friendship blossomed. Sessions for the portrait, often late at night after dinner together, lasted months, with Freud destroying his efforts if they didn't satisfy him. Even with the veteran painter, there were rumours that something more than friendship had developed.

Hack had to deal with the press constantly wondering why he and Moss didn't marry. Said Kate, "Every two weeks someone says we are planning a wedding, but it's not true. I wish people would stop going on about it." One late September lunchtime, Kate was in a Primrose Hill restaurant with Jude Law and Sadie Frost when Jefferson Hack drove up in her Range Rover. He then took Kate and Sadie to a private hospital for the birth. On Sunday, 29 September 2002, Lila Grace was born, weighing six and a half pounds. "I had simply the best birth," said Kate. "Candles and everything. A bottle of Cristal champagne. I had the best time."

KATE MOSS
THE BEAUTIFUL & DAMNED

THE BEAUTIFUL & DAMNED

A LIVE-IN NANNY was ensconced even before Lila Grace was named. Within weeks, Kate was back at work and partying on. She took yoga and pilates courses and swiftly got back to her pre-pregnancy weight. The relationship with Lila Grace's father, however, was less than idyllic. Hack's father complained that Kate was capricious and demanding, wanting to go out every night and jet off on holidays on a whim – basically, to continue with the lifestyle to which she had become accustomed. Hack didn't want to take his eye off the ball with his own business, and seemed intent on not living off Kate's money; some have said she expected him to pay for everything anyway, despite her vast wealth.

The tension between the pair was noticed by all at Stella McCartney's wedding in Scotland the following August, and Hack's parents visited Kate's home only to find her going out, leaving Hack holding the baby. Jude Law, who was now at loggerheads with Sadie Frost, refused to let his children attend Lila's christening, which took place in a Gloucestershire cottage that Kate and Jefferson had rented, and lasted three days and nights. By the time nine-month-old Lila was driven to church, the guests were trashed. "It was a wonderful service," gushed Marianne Faithfull. And then the adults carried on carousing. The villagers complained. Walnut Tree Cottage, reported its owners, was wrecked.

As Hack increasingly found himself mocked by friends as "the babysitter" or "the chauffeur", Lila Grace's parents' relationship was forced to redefine its boundaries. For all of Kate's new-mum, post-rehab promises – "I can't do that Paris-London-Milan cycle any more. I got tired of feeling like Dracula. I wanted to see some daylight" – she'd reverted to her familiar groove. The *Mail on Sunday* quoted friends of Hack saying, "She continually humiliated him, when he was nothing but nice to her. He really wanted to marry her." Others claimed she treated him like a PA, and "taunted him when she went off with other lovers". "She sees herself as a free spirit," said another, in Kate's defence. By March 2004, it was clear that they weren't love's young dream. (Kate consoled herself by pole-dancing in her undies for the White Stripes' video of "I Just Don't Know What To Do With Myself".)

Moss won custody of Lila Grace but Hack was given full and regular access, with his daughter staying with him every other weekend. Yet this wasn't entirely as a result of mutual agreement: there was money involved. The *Daily Mail* reported that Hack was paid £1 million (and given a £1-million property near Kate's home) to sign a "gagging" form, whereby he wouldn't reveal anything to the media about what had gone on during his relationship with Moss. "Kate and Jefferson remain friends," stated a press release. Yes, but at a price. Wounded, but considerably richer and more well known, the father of Kate Moss's child moved out of her St John's Wood house.

The views that Hack had taken in of Kate's 30th birthday party that January probably offered enough decadent glamour to last a lifetime. Even three years later, *Harper's Bazaar* ranked it as their

Page 96 Baby love: Kate and Jefferson Hack with their daughter Lila Grace, visiting New York in May 2003.

Below Yummy mummy: Kate with Lila Grace in London's Primrose Hill, February 2003.

THE BEAUTIFUL & DAMNED

Right Back on the front row: Kate sits between Jefferson Hack and photographer Mario Testino at a Burberry fashion show in 2006.

third most scandalous party of the last half-century, going so far as to compare it to Sodom and Gomorrah, the fall of Babylon and the last days of Rome.

When Marianne Faithfull encouraged Kate to read F. Scott Fitzgerald's novels of 1920s romance, yearning, hedonism and fatalism, it wasn't *The Great Gatsby* that fired the model's imagination but *The Beautiful and Damned*. She decided to make that title the theme of her party, a party that she hoped would outshine even her 21st at The Viper Room in LA. If that had been initiated by Johnny Depp, this was to be the 30-year-old Moss's own creation. She wanted an event that everyone would remember for years. With the considerable organizational help of PR guru Fran Cutler, Agent

THE BEAUTIFUL & DAMNED

Left Damned beautiful: Annabelle Neilson and Naomi Campbell at Kate's 30th birthday party, January 2004.

Opposite Kate arrives at the home of Agent Provocateur co-owner Serena Rees during the extended birthday celebrations. It turned into quite a late and memorable night.

Provocateur's Serena Rees, artist Sam Taylor-Wood and then-husband Jay Jopling, she got one. Any angst Kate may have had over reaching a milestone age was wiped out by her perennial code for living: fun, fun, fun. "One of the most shocking nights of debauchery ever seen in London," shrieked one journalist (who probably should get out more).

The party began at noon and, naturally, continued well into the next day (and for some, beyond). First, Kate lunched at the Mandarin Hotel with Jefferson and best gal-pals Sadie Frost, Meg Matthews and Stella McCartney. Then she greeted guests (130 of them) at her suite at Claridges in Mayfair (she'd booked out two of the expensive seventh-floor suites), receiving expensive gifts bearing all the "right" brand names (Dolce & Gabbana, Bulgari, Cartier, Agent Provocateur, a £300,000 diamond necklace in the shape of the figure 30 from Louis Vuitton). From the father of her child, a telescope with which to look at the star he'd had named after her. Caviar and champagne. Thirty kinds of fish (flown in from around the world), served by 30 waiters.

Working a look inspired by Gloria Patch, the flawed beauty at the centre of *The Beautiful and Damned* (Gloria "dances all afternoon and all night", chain-smokes, flirts, and is described as "spontaneous" and like "a very charming child".... heaven knows what party-girl Kate related to there), Kate donned a blue, Thirties, sequinned dress and carried a long cigarette holder (at least until she forgot about it). In the evening, Kate and entourage moved on to the adjoining London homes of Taylor-Wood and Rees, which were connected by a private courtyard. With help from production designer and art director Michael Howells, one was themed "Beautiful"; the other dubbed "Damned". There was elegance, but also erotica.

On the stroke of midnight, male models brought in a profiterole birthday cake almost as tall as Kate, who stopped smoking long enough to blow out the 30 candles. Jools Holland tickled the ivories, encouraging an inebriated Kate to sing the standards "Great Balls of Fire" and "Summertime". Marianne Faithfull sang "I Get a Kick Out of Kate". Guests, including Naomi Campbell, Grace Jones, Alexander McQueen, Stella and Mary McCartney, Ronnie and Jo Wood, Chrissie Hynde, Janet Street-Porter, Michael Clark and Rhys Ifans, smiled along. Kate's mother and brother were there, as were Sarah Doukas (and Simon) from Storm, her "discoverers".

THE BEAUTIFUL & DAMNED

Above Kate becomes the face of Zara in their first UK ad campaign in September 2003.

Chris Martin and a very pregnant Gwyneth Paltrow understandably left early, but not early enough to avoid a scuffle with a photographer outside. It wasn't even 2 a.m. when the first complaints came about the noise being made. By 3 a.m., 50 friends took taxis back to Claridges to keep the party going.

According to the *Mail on Sunday*, the party then evolved into an orgy. "A tangle of bodies writhed on a king-size bed. Limbs tangled in abandonment," was just one of their journalist's tutting pronouncements. Yet by 4 a.m. Kate was back on the dancefloor. As dazed revellers staggered outside in the early hours, Sadie Frost particularly exposed, the paparazzi had a field day.

There were some who figured that this might be Kate Moss's last big hurrah on the party scene; that as a 30-year-old new mum she might now "settle down". They were, of course, completely wrong – even if, in March, she was among 185 women invited to Buckingham Palace, to attend a (women only) lunch hosted by The Queen, marking International Women's Day. Kate, in a vintage blue dress, arrived with Sam Taylor-Wood, and managed to behave herself in front of the likes of Margaret Thatcher, Cherie Blair, J.K. Rowling, Vivienne Westwood and Twiggy. And to fill a spare moment or two in September 2003, she signed a £2-million deal as the face of Zara, in the Spanish chain's first UK ad campaign. The same month, the American magazine W ran nine simultaneous covers of her – "the triumphant return of a superstar" – by various artists and photographers, including hallowed names from Alex Katz to Chuck Close. Commented the venerable Katz, "(she is) extremely ordinary: that's what makes her extraordinary". And a few weeks later she realized a teenage dream by appearing (on the

cover of *Q* magazine) with one David Bowie (whom she had mimicked, with an *Aladdin Sane* lightning flash across her face, for the cover of British *Vogue* in May 2003). "Two of the world's top-drawer icons brought together to bond over fast times and a mutual fascination with each other's mythical status," wrote Gareth Grundy. "Kate Moss is the most rock'n'roll of all supermodels."

If Kate's romance with Jefferson Hack had thrown a curveball to the ever-prying media, her next gave them a dream story as she hooked up with a future James Bond. Daniel Craig, then in his mid-thirties, wasn't yet licensed to clog up multiplexes as 007 when he and Kate reportedly began an affair in spring 2004. Although his Bond debut – *Casino Royale* – was two years off, he was already a star on the up, having appeared in a number of well-received films such as *Road to Perdition*, *Sylvia* and *Layer Cake*. He was now filming *Enduring Love*.

The Craig-Moss love wasn't to prove especially enduring, however, lasting only three or four months. There were, of course, the by-now customary press stories wherein "friends" spoke of how "desperately" Kate was infatuated with her latest flame. When their fling began, Craig had recently split from a seven-year relationship with German

Right Kate accompanies Daniel Craig, future James Bond, to an Alexander McQueen-hosted fashion event at Earls Court, London, in June 2004. The couple entered into a brief affair.

actress Heike Makatsch (of *Love Actually* success). He and Kate got together as he was shooting *Enduring Love* with Kate's friends and fellow Primrose Hill regulars, the actors Samantha Morton and Rhys Ifans. They enjoyed a trip to New York, spending days and nights "holed up" in a luxury hotel. There was another break together in Goa with Linda Moss, Sadie Frost and her new beau Jackson Scott. In June they attended an Aids charity event, designed by Alexander McQueen, at Earls Court, London, where Kate followed a raunchy Naomi Campbell performance on the catwalk. With dancer and choreographer Michael Clark, she ad-libbed some dance moves, wearing a black floor-length, skull-print dress. She was taken by surprise when Clark picked her up and slung her over his shoulder.

But the first bloom of lust had faded when Kate surprised Craig by turning up at the premiere of *Layer Cake* (at the Electric Cinema in London's Notting Hill) only to find him surrounded by admiring young women and either reluctant or unable to give Kate his undivided attention. The *Mirror* sneered: "It did seem rather desperate of her to be there… she wasn't even invited." After the press claimed to have spotted Kate smooching with US comedy-actor Johnny Knoxville at a Franz Ferdinand gig in New York, she and Daniel took a holiday in Formentera (in the Balearics), but while he may have been shaken, he was not sufficiently stirred. (In 2011, he married Rachel Weisz.)

By Christmas, Kate was spending time "as a family" with Jefferson and Lila, but when she organized a big New Year's Party at a Scottish castle, Hack wasn't invited. This was another one for her party friends – among them Rhys Ifans, Davinia Taylor, Danny Goffey and Mick Jones, the one-time Clash/B.A.D. guitarist, with whose wife Kate was friendly. Mick was now producing a band called The Libertines, who were attracting lots of attention, and enjoying the buzz swirling around them. Enjoying it as much as anybody was one of their frontmen, Pete Doherty.

If the rise to fame and riches of Oasis and the Britpop bands had now slumped into mainstream water-treading, a new young generation was eager to make a noise and upset a few apple-carts. They were, Noel Gallagher has said, "even more mental than we were… heroin and crack and self-harm". Kate Moss wasn't about to grow up with what is conventionally thought of as grace. In 2004, The Libertines were voted Best New Band at the NME Awards. Mick Jones had been hired to produce their debut album *Up the Bracket*, recorded in St John's Wood, near Kate's house. The stars were aligned. Soon The Libertines imploded in a mess of arguments and drugs, Pete Doherty forming a new group, Babyshambles. Five years younger than Kate, but similarly an Oasis fan, he'd already fathered a son with Lisa Moorish, who had shared an apartment with Meg Matthews and had had a child with Liam Gallagher. A heroin addict, a rehab regular, Doherty had been sentenced to six months in prison for burglary (serving four weeks). Kate saw this textbook bad boy perform with Babyshambles on a charity bill with her old pal Ronnie Wood at the Shepherd's Bush Empire. In January 2005, Mick Jones invited her to the nearby studio to meet his young charges. She found Doherty droll and charming, and after their paths crossed a couple more times, she invited him to play in a specially chosen "supergroup" at her 31st birthday party at her country house. The F. Scott Fitzgerald theme having been squeezed to within an inch of its life the previous year, she hit on a new – albeit again borrowed – motif. It was to prove prophetic regarding the next phase of her turbulent life. This time her party was to be inspired by the Rolling Stones' filmed gig-cum-carnival event of 1968, bearing the name: Rock and Roll Circus. Kate threw herself into her new role.

THE BEAUTIFUL & DAMNED

Above left and right Kate dances with Michael Clark at Alexander McQueen's Lighthouse Services charity auction in London, June 2004. She was startled when Clark picked her up and slung her over his shoulder.

KATE MOSS
ROCK & ROLL CIRCUS

9

THE ORIGINAL Rock and Roll Circus of December 1968 had featured The Rolling Stones, John Lennon, The Who, Eric Clapton, Jethro Tull and Kate Moss's heroine Marianne Faithfull performing in a big top. Kate, never one to worry about overdoing rock and roll cliché, decided her 31st would mimic this event, the film of which had finally been released in 1996. Her seventeenth-century farmhouse in the Cotswolds was suitably decorated, the barn draped in colours inspired by the film: she'd bought the property as somewhere to host parties away from London's media scrutiny. This one wasn't planned to be as ostentatious as her 30th, but the *Sun* nevertheless blared that it would be "Kate's wildest ever. Everybody will be decked out in glam rock outfits and booze will flow all night." Guests arrived by car to find the driveway adorned by long lit candles. Yet this year's guest-list was relatively intimate compared to the very public and celebrity-loaded London bash.

Among those running away to the join the circus were usual cohorts Sam Taylor-Wood and Jay Jopling, Samantha Morton, Sadie Frost, Pearl Lowe and hairdresser James Brown. Marianne, of course, was there, as was fellow Sixties and Stones-circle survivor Anita Pallenberg. Kate's mum and brother and Jefferson Hack showed up. Musicians from REM's Michael Stipe to Travis' Fran Healy too; and Shane MacGowan, who DJ'd, as did Mick Jones. Kate keenly wanted to present herself as a rock chick, perhaps trying a little too hard by singing on the circus stage with "her" band of Clash alumni Jones and Paul Simenon, with added vocals from Bobby Gillespie and one Pete Doherty. As ringmaster, Kate wore gold tails and top hat. James Brown (not that one) sang "Leader Of The Pack", dedicating it to her.

As Lila Grace slept somewhere in the large house with nanny close by, Pete Doherty and hangers-on took their favourite substances. He'd given Kate a birthday present: handwritten, framed lyrics to his song "What Katie Did". Contrary to popular belief, the lyrics weren't even about her, but about his ex-girlfriend Katie Moriarty. Was Moss mortified? She was not. She sat in his lap, the pair canoodling, and by the next morning she and Doherty were very much a couple, to the astonishment and even the alarm of many of her close friends. He was perceived as a train-wreck not so much waiting to happen as already very loudly and publicly happening. Considering the lengths Moss and her "people" had gone to for years to protect her highly marketable image, and keep her often less-than-wholesome nocturnal activities under wraps, her attraction to this dark enigmatic type – who made Johnny Depp seem like John-Boy Walton – was risky in the extreme. Doubtless, for her, that was much of the appeal. She had enjoyed being a fashion and art muse; now she wanted to be a rock muse, as Marianne had been.

Her management (like the media) weren't simply afraid that Pete would lead Kate off the rails: she had plenty of experience of her own there. What worried them was his noted lack of discretion: he had an untrustworthy clique and was often misguidedly candid with the press about both his drug problems and his love life. Yet they soon accepted that she was besotted. "I know he's bad for me," she soon admitted, "but I just can't help myself. There's something about him. I keep going back." His East London apartment was a picture of squalor, especially compared to her luxury homes, but this, too, only fanned the flames in her vision of him as a pale, tortured, Rimbaud-esque poet. He was also in love with her, but the drugs came first. Kate wrote him a poem including the saddening lines: "You love them more than you love me / So that's why I could cry all day, that's why I can't breathe."

Page 106 When Kate started "stepping out" with the erratic Pete Doherty, the popular perception of her underwent a seismic shift.

Above Kate held her hedonistic 31st birthday party – themed after the Rolling Stones' 1968 gig-cum-carnival event "Rock and Roll Circus" – at this country house in the village of Little Faringdon, Oxfordshire.

The fears of those around Kate were valid. It was, in many ways, their worst nightmare. The Doherty-Moss alliance became the alternative, grungy Posh and Becks, a kind of anti-establishment Bonnie and Clyde, with their ups and downs and rows and reunions filling the tabloids day after day for months, years to come. Even Doherty's mother pleaded, "I think everyone should leave them alone. They're deeply in love and people just won't leave them alone." Her argument would have held more weight if Pete hadn't sold stories along the lines of "My Drugs Hell" to the papers in order to fund his habit. Indeed, he now compounded the misjudgement my selling "My Love Bliss" tales for the same reason. "I believe her when she says she loves me and I know I love her," he swooned. Just a few weeks later, the *Sunday Mirror* and the *News of the World* ran photographs of him smoking heroin: Kate couldn't claim she hadn't had fair warning. Pete attacked the ex-friend who'd sold the pictures and was charged with assault, spending four nights in Pentonville prison. He was ordered to go to rehab, but couldn't afford to. Instead, he sold a story to the *Sun* newspaper, telling them he was doing this for "his angel" Kate.

Now Moss caught on to the fact that she really was playing with fire. She broke up with him for the first time, but eventually even the press lost count of how many times she finished the affair then rekindled it. Even while he was in rehab, pictures of him with Kate – stolen from his phone, he claimed – turned up in the papers, leading to a blazing Valentine's Day argument. There were insults and apologies, time and again. Upon finding her in a pub with Rhys Ifans, Pete launched into a tirade. "I'm a bit paranoid and insecure," he confessed. "But she's one of the most beautiful women in the world, so who wouldn't be?" Kate decided her best course of action, given that she couldn't

Opposite Kate and Pete at Glastonbury Festival, June 2005. Even in shorts and Wellington boots, she started a trend.

Above The real thing: in September 2005, Kate, exposed, had to deal with the biggest scandal of her career.

give him up, was to get him off the drugs (or at least what she deemed the hard stuff), before her fantasy of being the perfect rock-and-roll personality-couple crashed in a mess of embarrassment and vomit.

The circus continued. Summer of 2005 saw them established as something akin to the Sid and Nancy or Kurt and Courtney of their generation. Yet their appearances at rock festivals sporting a less than minty-fresh look somehow led to Kate surfing the wave of another zeitgeist. For all its dangers, her romance with Doherty was achieving the improbable: raising her profile even higher. It was a high-wire act. They "married" in a mock ceremony at Glastonbury music festival, where Kate's hotpants and Wellington boots marked a new, much-copied "boho-chic" look. On a Eurostar train to Paris, where Pete was meant to support Oasis, they fought so badly that he gave up on making the gig and went home. His career was either exploding or imploding, depending on whether you judged it in column inches or successful records and shows. In July he blew a duet of T. Rex's "Children of the Revolution" at Live 8 with Elton John, the latter remarking archly after Doherty was booed, "Well, at least he looked good." The new Babyshambles album was floundering amid Pete's problems and distractions. He only managed to eke out a single, "Fuck Forever". A song titled "La Belle et La Bête" soon followed, interpreted as being about Pete and Kate, though it wasn't. On it, Kate sang, "Is she more beautiful than me?" She even (nervously) sang it onstage with him in Dublin. In Cannes, they trashed a hotel room with Bobby Gillespie and his girlfriend. Nonetheless, Pete optimistically told the press, "I love Kate very much. We're definitely going to get married. We're trying for a baby together." He moved his belongings into Kate's farmhouse, pining for her when she was away working. And in a note to him, Kate wrote: "You have touched my heart and soul, little fucker. I wish you wouldn't ring my door; go now. I could kiss you again and float away. You make me high, my sweet; my skin shivers and longs to be held by you."

And then the storm broke. It seemed as if Kate Moss's magnificently finessed brand and career might be over when, in September 2005, the *Daily Mirror* ran the notorious exposé with the headline "COCAINE KATE". She and Pete were in New York when it emerged; she'd been working at fashion week. There was a shoot with Maria Sorrenti for *W* magazine, and

Left Hiding in plain view: Pete and Kate – still entangled – wearing Philip Treacy masks at a Moët & Chandon ball at Strawberry Hill, outside London, October 2006.

ROCK & ROLL CIRCUS

the launch of *AnOther* magazine, Jefferson Hack's new offering. Kate enjoyed seeing lots of old friends, but Pete mostly preferred to stay indoors at the hotel. Early on 15 September, it fell to Sarah Doukas to call her to break the bad news. When Kate had joined Babyshambles at the Metropolis Studios in London's Chiswick nine nights earlier, someone had covertly filmed her chopping up lines of cocaine with a credit card, then snorting one and sharing the rest around. (The film also, incidentally, showed her drinking vodka, whisky, beer and wine. The chain-smoking goes without saying.) Having used up COCAINE KATE as their lead headline alongside incriminating grainy stills, the newspaper opted for HIGH AS A KATE inside. She had "a mammoth stash, kept in her handbag…"

Kate was, recalled Doukas, "… gutted. Absolutely gutted." "She has always been an unbelievably private person," she added defensively. "I've never seen the side of her that they've written about. She's always gone to work every day… and her schedule has always been really tough." But Moss's guard had slipped, her calculations warped by Doherty's seemingly magnetic pull on her senses. The media perhaps had felt that recent displays of feisty arrogance (she had sued the *Mirror* a year earlier for suggesting she used Class A Drugs) meant that she was no longer off bounds. They had adored the chic London party girl but less so the multi-millionaire with the junkie boyfriend. They labelled her a liar and a hypocrite, and also mentioned at every opportunity that she had a two-year-old daughter.

Below Rather timidly, Kate takes the stage to contribute backing vocals at a Babyshambles gig in Florence the same month.

Left Bonnie and Fried in Gloucestershire, February 2007: Pete, in character, throws beer at chasing photographers as Kate drives the getaway car.

Opposite Back at the Glastonbury Festival in June 2007: Doherty and Moss somehow stagger on.

It was, briefly, open season on Moss. Two days later, the *News of the World* ran with: "Cocaine Kate's 3-in-a-Bed Lesbian Orgies" (citing Sadie and Davinia). Would all this destroy her brand? Would advertisers flee, aghast, from this "bad role model"? At first, it seemed so. H&M swiftly dropped her from their forthcoming ad campaign for the new Stella McCartney range; there were several knee-jerk reactions and lost contracts. And yet, after all these coke and sex and rock-and-roll scandals, somehow the "edgy bad girl", "the Keith Richards of modelling", seemed more attractive to advertisers than ever.

In Kate's case, any publicity is good publicity. Her charmed life continued. A strategic spell in rehab and a half-hearted apology-of-sorts (which we'll come to later) took care of the PR side of things. Her fame was ballooning again, and big money, which had already invested heavily in her, wasn't about to burn its bridges over a juicy scandal. In a remarkable twist, the year following the Cocaine Kate debacle saw her bagging around £30 million in income. She was snapped up as the face of no fewer than 14 advertising campaigns, including Rimmel, Virgin mobile phones, Stella McCartney, Versace, Burberry (who'd declared they were dropping her, then performed a volte-face), Nikon, Belstaff, Longchamp, Louis Vuitton, Bulgari, David Yurman, Christian Dior and (again) Calvin Klein jeans. Her breakthrough Topshop designer deal was around the corner too. Ironically, far from being damaged goods, she was hotter than ever. A career that, in the modelling world, may have been approaching its expiry date, was rejuvenated.

ROCK & ROLL CIRCUS

Dior

LONDON / BIRMINGHAM / MANCHESTER / DUBLIN / HEATHROW AIRPORT
WWW.DIOR.COM / TEL. 020 7172 0172

Opposite Kate shines in a 2005 magazine ad for Christian Dior.

Above Up, up and away: the Moss–Doherty phenomenon and their private helicopter, now departing from Newquay airport in Cornwall.

Once again, reinvented by default, Kate Moss had done everything wrong and got everything right. As for Pete Doherty, he staggered (literally) on. His bond with Kate survived that scandal and a few dozen lesser ones. By 2007 he had got his act marginally more together, was playing shows and still dreaming of a long-term future with her. She sang with him at a gig that April and, from the stage, he announced their engagement. She'd apparently agreed to marry him on condition that he stayed off the drugs. She reckoned she had kicked them and he had to match her. He visited rehab and detox clinics doggedly. "I love this girl so dearly, and that's why I'm in this clinic," he wrote in his book *The Books of Albion: The Collected Writings of Peter Doherty*. "We shall marry in the summer and I will be ten times happier than any given smackhead. Huzzah!" Yet before long he was admitting to "moderate and controlled" use. He knew Kate would be furious. Also unhelpful were arrests on suspicion of stealing a car and for driving without insurance or tax, and charges of possession of crack, heroin, ketamine and cannabis. Just before another court-ordered rehab stint, Kate's patience, after two

Above Doherty's writings enchanted Kate, but the couple were now breaking up more often than they were making up.

and a half years, finally gave way. The pair watched a trailer together for a film about him, and as footage of him flirting with groupies flickered on, Kate went "ballistic", in Doherty's words. "We fell out for the same old reason. She's got an awful temper. I said, 'I'm never going to be treated this way again.'"

Soon, removal men were spotted moving his gear (musical instruments, suitcases) out of her London house. "I was always dodging bullets. It became like the Vietnam War," Doherty gallantly told the press. So distressed was Moss that she cancelled an appearance at a Galliano show for Dior in Versailles. (With Galliano now disgraced for anti-Semitic outbursts, there were multiple interpretations of this.) She had her locks changed and hired security guards to deny Pete access. Pete was stricken with remorse, using the papers to plead with the last of the English roses to take him back. "I can't get hold of her any other way. I need Kate to know that I still love her. She has broken my heart." Forfeiting his last shred of dignity, he added, "Take me back. I'm here to tell her that I love her." But this circus had now left town. He sank into the familiar spiral of relapse. By October 2007 he was engaged to the model Irina Lazareanu, who, as a mutual friend, had been given her big break by… Kate Moss, who had chosen her to model her Topshop range.

To this day, Pete Doherty ambles and shambles on, no longer the voice of a generation but (very) arguably something of a bedraggled national treasure. His latest single is called "Picture Me in a Hospital". He recently opened a shop in Camden Lock, north London, selling artefacts and memorabilia, among them items like tissues with Kate's lipstick on.

Right Pete, remarkably, turns up at his own book signing for *The Books of Albion* at Red Snapper Books in London, June 2007.

KATE MOSS
DON'T CALL IT A COMEBACK

Page 120 Red hot: Kate makes a cameo appearance at the launch of her Topshop clothes range.

Below I fought the law: Kate arrives for questioning regarding alleged cocaine abuse at a police station in Victoria, London, January 2006.

IN THE FIRST FEW DAYS after the Cocaine Kate scandal broke, Moss had phoned Jefferson Hack repeatedly from New York. He was taking care of Lila at his parents' home in Ramsgate, Kent. He put Lila on the line and Kate's young daughter told her she loved her. The child's innocence, combined with the massive media hullabaloo, persuaded Kate it was time – again – to try to seriously detox. After a series of urgent meetings with her agents and lawyers, tailed by even more paparazzi than usual, she issued a fire-fighting statement, presumably scripted by Sarah Doukas. "I take full responsibility for my actions. I also accept that there are various personal issues that I need to address and have started taking the difficult yet necessary steps to resolve them. I want to apologize to all of the people I have let down because of my behaviour, which has reflected badly on my family, friends, co-workers, business associates and others. I am trying to be positive, and the support and love I have received are invaluable." Hardly self-lacerating, the stance did just enough. A police inquiry, costing £250,000 and lasting over six months, during which Kate was interviewed under caution at Scotland Yard HQ, came to naught: despite the obvious, there was no proof that the white powder she was snorting in the photographs and

video was cocaine. Teflon Kate jumped through the obligatory hoops, spending 30 days in rehab clinic The Meadows in the Arizona desert. Her mother visited, as did Jefferson, with Lila, whose third birthday Kate had missed.

Doukas was desperately battling to re-boot her star's career. French *Vogue* kept to their plan to use Kate as "guest editor" for their first issue of 2006, turning it to their advantage with the strapline "Kate Moss: Scandaleuse Beauté". *Vogue* also ran a supportive shot of Alexander McQueen wearing a "We love you Kate" t-shirt on a Paris catwalk. The editor's letter called her "this young English girl (who) could have come straight from the pages of a Bret Easton Ellis novel. She is, nevertheless, the most inspirational icon and muse." Pirelli used her for their calendar, and Richard Branson supported Doukas again by having Kate star (in those hotpants) in a Virgin Mobile TV ad campaign. This used sly, knowing catchphrases like "don't call it a comeback" and "one contract worth keeping". Branson-as-vested-interest is a rich and powerful ally. The war was being won; the fashion world had closed ranks and saved their darling. As we've seen, far from taking a hit, her earnings sky-rocketed… another £½ million to reunite with Calvin Klein, £1.5 million from Nikon, £3 million from Rimmel: she

Opposite right Designer Alexander McQueen comes out in support of the beleaguered model in Paris, 2006. She appeared as a hologram projection in the designer's Autumn/Winter 2006.

Left Kate with the loyal McQueen at the Pharmacy club in London a few years earlier.

was crying all the way to the bank. Photographer of rock lore Mick Rock remarked, "She wanted to be the Keith Richards of the modelling industry – and she got there!"

Comeback Kate, the "bad girl", had even emerged from all the fuss seemingly "sexier" than before. For Agent Provocateur, she shot four short promotional films with director Mike Figgis, which were released online throughout 2007. Kate's character was Miss X; her role: to play out her erotic fantasies while wearing the line's lingerie. The first film proved so popular it crashed the website. "Kate Moss's knickers-flick crashes net," gasped one headline. (Eventually the films were released as a DVD set.) *Time* magazine listed Kate as "one of the world's hundred most influential people". (Meanwhile, Pete Doherty muttered, "People are obsessed with my missus, I don't know why… she's just a bird from South London.") Her birthday parties became relatively more subdued (if you can call a party at The Ritz in Paris with Naomi Campbell and other "close friends" subdued).

Restless Kate had to keep atypically still as sculptor Marc Quinn oversaw a plaster cast of her body and crafted his gold yoga-pose statue of Kate, entitled *Sphinx*. He cited her as "a contorted Venus of our age" who showed us "a mirror of ourselves". And yet, in late 2007, the *Sun* reckoned the boom brought on by the Cocaine Kate scandal was running out of momentum. "She is still very big, but the honeymoon period has ended." She didn't turn up to collect her Model of the Year award, instead sending Vivienne Westwood to accept it for her from Bryan Ferry. As the doomed romance with Doherty twitched its last few death throes (her onstage routines with him were mocked as "*Spinal Tap* for the Noughties"; she was booed in Florence), she had a fling with the notorious womanizing actor-comic Russell Brand, also a former (heroin) addict. In one of his less gallant decisions, he offered a kiss-and-tell in his book *Booky Wook 2: This Time It's Personal*. "I had a mad infatuation with her," he wrote. "It didn't feel like a conquest, it felt like I fell down a well. I was like a twelve-year-old again. I felt totally overwhelmed because she is obviously incredibly beautiful – and she is Kate Moss. The next day, ludicrously, I had to get up and live my normal life."

What Katy Did Next wasn't defined by her love life (or not completely), and was to light the way to her extended career as designer as well as model. Sir Philip Green, Topshop owner and retail fashion mogul, had,

Above Kate's Agent Provocateur short films proved so popular that the website crashed.

Opposite On the catwalk without even attending: Kate's face appears on a dress in Jean-Charles de Castelbajac's Autumn/Winter 2006 show. Her iconic status is confirmed.

DON'T CALL IT A COMEBACK

Right With new best friend Sir Philip Green at the triumphant launch of her Topshop range in May 2007.

at a charity auction in May, bid £60,000 to kiss Kate (though he then passed on the prize to rival bidder Jemima Khan). Two weeks later, Green and Moss crossed paths at The Dorchester hotel, and Kate chirped up, "I'm a girl from Croydon, you're a boy from Croydon – we should do something together." Seeing his interest was piqued, she added, "I've always wanted to do my own clothing collection." A few days afterwards, the then fifth richest man in Britain took a meeting with the world's most famous style icon. For once in her life, she had to do the pitching. A second meeting ensued (with Doukas present) at which Green demanded assurances that Kate was serious about the project and prepared to commit the considerable time and promotion necessary. He got affirmative answers, but still Green took until August to mull it over. Was she too risky for his business? Further meetings and negotiations took place, with Moss suddenly learning what it was to be wanting something without the certainty of getting it simply because she was who she was. He made her jump through hoops: attending Topshop's fashion show (which previously would have been deemed beneath her) and smiling as the cameras clicked. Seeing the snaps, the press speculated that she'd be modelling for the brand. Then came the announcement: the launch of the Kate Moss Topshop collection was on the way. (Green's previous designer of eight years, Jane Stephenson, called "the most important woman in fashion" by *Drapers* magazine, promptly left in protest at the "celebrity signing".) For Green, Kate meant publicity and inroads into international markets. For Kate, the deal meant £3 million, plus royalties on sales and a chance to prove she was more than just a product of clever stylists and photographers. Her first "line" (cue media sniggers) opened at the Oxford Street branch in London's West End. She wasn't about to learn a new trade overnight though: her name was the

Above As Kate pocketed a cool £3 million plus royalties for her deal with Topshop, thousands crowded outside the store in a display of "Mossmania".

selling point. A "ghost designer" was brought in at her request: her friend Katy England, now wife of Bobby Gillespie. Kate had read a poem at their wedding the previous summer. England had worked as a stylist for Jefferson Hack's magazines, and for Alexander McQueen. (She still styles Kate, as evidenced by a summer 2013 *Esquire* cover shoot.)

Although Jane Stephenson was to say, "The whole thing of looking at what celebrities are wearing is so dull and unimaginative and desperately boring," Green seems to have insisted Moss put the hours in. He kept Pete Doherty well away from his brand, and his exit from Kate's story was now inevitable (though, of course, there were still a few make-ups and blazing rows). Kate's first Topshop designs (90 pieces) mimicked her own wardrobe and that of others; her second batch drew less flak. Little matter: they were marketed with supreme aforethought and precision. The Oxford Street preview saw her join the mannequins in the window briefly, wearing a red satin sheath dress. Her mother looked on proudly as a feverish crowd of thousands blocked central London. It was nothing short of Mossmania. Within a week, the collection had made big money. Kate's Midas touch was back. To her delight, females from 15 to 50 were now "wearing" Kate Moss. Soon she launched her own successful perfume too, which she described as "feminine, a bit rock'n'roll, a bit edgy, a bit light, a bit dark".

To compound the comeback – and the new chapter – images of Kate (by Corinne Day) hung in the National Portrait Gallery. (Sadly, the photographer, who arguably "made" Moss, died in August 2010.) Kate's latest quest for domination of the "arts" continued with the new Babyshambles album, *Shotter's Nation*, which even credited her with co-writing some of the lyrics – but this was her last entanglement with Pete.

Opposite Jamie Hince and Kate Moss attend the Chanel Ready-to-Wear Autumn/Winter 2009 fashion show during Paris Fashion Week, March 2009.

Right An enthusiastic Kate and model Susie Bick join Kate's husband-to-be Jamie Hince onstage at a charity gig in Oxfordshire, July 2010.

By 2008, she was included in *Who's Who*. At the Philip Green-hosted party at Annabel's nightclub in central London, launching her second Topshop collection, a new partner, Jamie Hince, accompanied her. He wasn't her first rock-band-member boyfriend, but he was to become her first husband.

Kate and Jamie had met through his ex-girlfriend and current bandmate in The Kills, Alison Mosshart. If you think that's strange, Mosshart was now dating Jefferson Hack. Yet friends and family were pleased and relieved. In their eyes, Hince had all the rock-and-roll elements that Kate craved (at the risk of making him sound like her promotional platitudes for her perfume) as well as some of the counter-cultural artiness and intelligence, but without the self-destructive urges of Doherty. He was 38: a grown-up, comparatively.

Not that Kate was easing up or (that dread phrase) "acting her age": her 35th birthday party in January 2009 lasted a long, long weekend. At its "opening night" at the Dorchester, an almost-surreal list of celebrity guests included Lionel Richie (who sang for her), the English footballer Peter Crouch and his wife, model Abbey Clancy. The next night, Kate's festivities continued at her home with friends. Jamie gave her a Steinway piano. Neighbours complained about the rising noise levels; an ambulance was called. Just like old times.

"People that don't know me get 'Mossed'. It means: I was going to go home, but then I just got led astray. In the best possible way, of course."

KATE
MOSS
THE BRIDE STRIPPED BARE

THE NEW FRAGRANCE BY

Kate moss
PARFUMS

VINTAGE

KATE'S MID-THIRTIES

saw no let-up in her fame or confidence, and, while nurturing her new "mature" role as a designer (Topshop smartly extended her contract and she helped with her collection's New York launch, at the chain store Barneys), she added further lucrative commissions to her modelling resumé. The world's biggest fragrance company, Coty Inc., announced "the signing of supermodel and fashion icon Kate Moss as their latest beauty partner to develop and market her own line of signature fragrances… (she) epitomizes the look and feel of today's fashionistas." She was the face of Parisian jeweller Fred Joaillier, of Just Cavalli, of Mango, and of Stella McCartney's collections. Alongside Gisele Bundchen, she fronted Versace's 2009 campaign. She saves dresses she's given for Lila, who is "like I was then… but much more outspoken". Recently she's even "created" a range of accessories (dubbed "fashion-tech") for Carphone Warehouse.

She occasionally spoke of trying other careers – "I've got lots of friends in the music business and they're always asking me to do things. Obviously one day I'm going to stop modelling" – but the Topshop triumph snowballed into other design offers, her brand name being all-important. "I would love to offer Kate Moss a recording contract whether she can sing or not," said Simon Cowell, "It's the Kate factor." (Over the years she's appeared on records by Oasis, playing tambourine, and sung with Primal Scream, The Lemonheads and, of course, Babyshambles.) In 2012, she added another music-video role to her lengthy list, appearing in George Michael's "White Light".

Movie scripts have been offered: so far she's resisted the temptation. When Marc Quinn revisited his muse and unveiled his £1.5-million, 18-carat gold statue of Kate, *Siren*, in 2008, he remarked, "What's interesting about Kate is that there are 50 billion images of her, but no single iconic one. There can't be, because she is legion."

October 2010 saw her appearing on the cover and inner booklet of Bryan Ferry's album *Olympia*, shot by Adam Whitehead, in images referencing Edouard Manet's famed synonymous 1863 painting. An exhibition of these Kate shots ensued. Ferry, as frontman of Roxy Music, has a proud heritage of using fashion imagery and glamorous women as "sleeve art", and all the stops were pulled out here. "Couture by Galliano at Dior, mask by Philip Treacy, art director Bryan Ferry." The cigarettes were presumably the model's own. The shots also tipped a nod to the first ever Roxy album cover, a classic of the genre. Moss, opined many, had never looked more beautiful.

"Normally we'd try to choose an unknown as this glamorous icon figure," Ferry told me when I interviewed him. "But this time, why not go for the icon? She's perfect for this." At the album's launch party we'd seen multiple images, and I asked if it'd been difficult to choose the cover portrait. "Well, we did have lots of arguments choosing!" he laughed. He

Page 130 In for the Kills: Jamie Hince escorts Kate to a Mario Testino private view, July 2010.

Opposite Kate launched her own perfume, Vintage, in 2009.

Below "She's perfect for this," said Bryan Ferry, as Kate's image adorns his new album *Olympia*, released in October 2010.

THE BRIDE STRIPPED BARE

Opposite Sporting – and featuring on – one of Stella McCartney's official Red Nose Day 2013 T-shirts.

Above left Kate and Jamie at the 10th anniversary ball of Jefferson Hack's *AnOther* magazine, February 2011.

Above right Sending herself up as "Katie Pollard" with Little Britain's Matt Lucas.

described how, upon seeing the image-as-advertisement on a huge electronic billboard near Shepherd's Bush roundabout, he drove around and around a few times to take it in. "It was fabulous… I thought it was the best visual thing we've ever achieved really."

Kate could now do "goddess" in her sleep, even to the demanding levels of "Roxy girl". By contrast, possibly her most memorable, self-deprecating moment as an "actor" was her cameo in a charity performance of David Walliams-Matt Lucas comedy *Little Britain*, at London's Hammersmith Apollo, shown on TV for Comic Relief in March 2011. She played Katie Pollard, the younger sister of Lucas' inelegant character Vicky Pollard, and wore a "polyester sports-top with skin-tight leggings and lashings of gold Creole jewellery". Her best line? "I'm the easy one, I'm a total slag. I'll do anything for a packet of Quavers." She then went "off on the rob". Vicky Pollard yelled, "Lose some weight, you fat bitch."

Showing a public willingness to spoof yourself (and your image) is a short-cut to likeability in the UK psyche, especially if it's for charity, and the *Little Britain* gambit worked. If Moss had been too strict before, she was lightening up now. There has also been a catalogue of charity work over recent years: she's supported the Elton John AIDS Foundation, Make Poverty History, Cancer Research UK, Warchild, Breakthrough Breast Cancer and the SamandRuby foundation, which she helped launch in 2006, and so many other causes that it would take pages to list them.

Maybe the only thing she hadn't yet done was get married, and this oversight was rectified on 1 July 2011, when Kate married Jamie Hince. There had been false alarms in the press for some time, but that February Jamie had proposed to her with a vintage

135

THE BRIDE STRIPPED BARE

1920s ring worth £10,000. Not that cost was the issue: Kate had recently bought a £7.5-million, seven-bedroom property in Highgate, London, in which the poet Samuel Taylor Coleridge once lived, and the married couple are still there.

Vivienne Westwood told an interviewer that Kate would be designing her own wedding dress: "She has done her own fashion range and she knows about clothes; she knows what she's doing, she doesn't need my help." In the event, Moss wore Galliano, a sign of her loyalty, given the designer's recent disgrace (he'd been suspended by Dior for drunken, anti-Semitic remarks). Even on her big day, the lifelong model looked to him for "direction". "On my wedding day, I'm freaking out, obviously," she said. "'You've got to give me a character!' And he said, 'You have a secret – you are the last of the English roses. Hide under that veil. When he lifts it, he's going to see your wanton past!'"

The village of Southrop in Gloucestershire was transformed, with a heavy police presence, roadblocks and a no-fly zone imposed to keep away photographers. (Bride and groom contributed "towards additional policing in order to reduce the impact on the taxpayer", said a police spokesman). Mario Testino was the official photographer. Lila Grace was among the 15 bridesmaids. Guests included friends old and new, like Westwood, Philip Green, Naomi Campbell, Bryan Ferry, Stella McCartney, Jude Law, Sadie Frost, Kelly Osbourne, Jefferson Hack… no Pete Doherty, though; he was in prison for drugs possession. The wedding was followed by a three-day party – pretty much a mini-festival, in marquees behind the house – nicknamed "Mosstock". Entertainment, it was reported, was provided by Iggy Pop, Beth Ditto, ex-Libertine Carl Barat and Snoop Dogg.

Below Wedding belles: bridesmaids galore at Kate and Jamie's wedding in the village of Southrop, July 2011.

Opposite Sealed with a kiss: Moss is married, and a three-day party ensues.

Married Kate was now a national treasure, and this was confirmed when she popped up at the London Olympics closing ceremony in August 2012. In a celebration of the best of British culture, with David Bowie's "Fashion" blasting out, Kate, Naomi Campbell, Lily Cole, Jourdan Dunn and Georgia May Jagger represented the fashion world, showing off shimmering gold outfits. The high-end coffee-table book *Kate: The Kate Moss Book* was launched in November 2012, featuring photographs from across her career, which she'd chosen herself, including many previously unseen.

Not so much of a national treasure that she couldn't still cause a ruckus, however. In February 2013, the 39-year-old took part in a photo shoot for *W* magazine, which offered the intimate sight of Moss and pop star Rihanna nuzzling together in lingerie with no shortage of Sapphic conviction. *Esquire* ran Craig McDean shots (styled by Katy England) on its cover with the heading "Kate Moss Rocks ("[she] has for 20 years been our generation's ideal of feminine beauty and glamorous hedonism"), recalling that the last time she'd appeared on the cover of a men's magazine had been two decades earlier, when she was just 19, and covered in gold body paint. And gold was key to one of her most striking magazine covers yet, when in August 2013 her third appearance for fashion bible *POP* revealed a landmark collaboration with artist Allen Jones, in which she not so much wore as inhabited a metallic glitter bodysuit, first created by Jones in 1978. The image went on auction at Christie's in September, along with other legendary photos, paintings and sculptures. Said the curator, Gert Elfering, "Kate is the ultimate modern muse, and we will be seeing her images in major museums and private collections for years to come. She has altered perceptions for women across the globe, encouraging them towards greater individuality and expressive freedom. There is so much you can learn from Kate: how you should always remain true to yourself, develop your own style, and emphasize your individuality."

As rumours swirled that she might mark her 40th birthday (in January 2014) with a debut appearance in *Playboy*, the Kate Moss empire shows no signs of crumbling. Model of unique longevity, designer of startling success or rebel without a cause, headlines seem to be hers at the snap of a finger. Smartly, even though courtiers come running, she's generally avoided interviews, allowing others to project mystique onto her. She has, however, dipped her toes into the publicity ocean more frequently of late, and did break her silence with *Vanity Fair* in December 2012. Kate talks!

"I don't want to be myself, ever," she told trusted friend and Keith Richards' biographer James Fox. "I'm terrible at [being in] a snapshot – terrible! I blink all the time; I've got facial Tourette's. Unless I'm working and in that zone, I'm not very good at pictures really." On a normal day, she wears grey, or black jeans, now, she added, to bore the paparazzi, because "then they leave you alone". And there are hints that, at this landmark birthday, the ageless Kate Moss might secretly be opting for the peaceful life, albeit in a state of grace. "I don't really go to clubs any more. I'm actually quite settled: living in Highgate with my dog and my husband and my daughter." Let's not shatter the illusion, though. "But don't burst the bubble. Behind closed doors, for sure, I'm a hell-raiser!"

Below and opposite Kate Moss, the survivor, at the launch of Rizzoli New York's *Kate Moss*, hosted by Marc Jacobs, November 2012.

Overleaf Golden years: at the age of 39, Kate becomes the new "face and body" of St Tropez tanning.

Index

Page numbers in *italic* refer to illustration captions.

A
Adams, Bryan 90
Adweek 47
Agent Provocateur *100*, 101, 124, *124*
Allison, Lori Anne 62
Anderton, Sophie 86
AnOther magazine 113, 135
Avedon, Richard 6

B
Babyshambles 104, 113, *113*, 127, 133
Bailey, David 9
Banksy 5, 6
Barat, Carl 136
Belstaff 114
Bick, Susie *129*
biographical details
 birth 15, 16
 early life 16–17, 19, 21
 education 16–17, 27, 31, 32
 pregnancy 94, *94*
 marriage 135–6, *136*
 see also family; life and lifestyle; modelling career
Blumarine 69
books about Kate 62, *65*, 138
Bowie, David 6, 21, *21*, 103, 138
Brand, Russell 124
Brando, Marlon 59, 76
Branson, Richard 24, *59*, 123
Brides magazine 27
Brinkley, Christie 26
Brown, James 39, 62, 108
Bruni, Carla 42
Bulgari 114
Bundchen, Gisele 133
Burberry 89, *89*, 91, 99, 114
Burchill, Julie 6

C
Campbell, Naomi 30, 31, *31*, 52, *59*, 60, 62, 66, 70, 80, *80*, 82, *100*, 101, 104, 124, 136, 138
Carphone Warehouse 133
Castelbajac, Jean-Charles de *124*
Castro, Fidel 80, 82
Chambers, Simon 24, 26, 49, 101
Chanel 40, 52, 56, 79, 91, *91*, 129

Chapman, Jake and Dinos 89, 90
Chloé 9, *70*, 88
Christensen, Helena 62
Clancy, Abbey 129
Clark, Michael 101, 104, *105*
Close, Chuck 102
Cole, Lily 138
Collman, Geoff 21
Cordell, Tarka 76
Cosmopolitan 49, 52
Coty Inc. 133
Cowell, Simon 133
Craig, Daniel 103–4, *103*
Crawford, Cindy 26, 49, 52
Crouch, Peter 129
Croydon 9, 14–15, *16*, 39, 52, *59*, 126
Cutler, Fran 99

D
D'Argy Smith, Marcelle 52
Daily Mail 14, 98
Daltry, Roger 60–1
Day, Corinne 27–8, *28*, 31, 36, 42, 49–50, 52, 93, 127
Dazed & Confused 56, 88, 90
Demarchelier, Patrick 39
Depp, Johnny 9, 52, 56–69, 74, *74*, 75–6, 77, 79, 82, 89, 90, 93
Depp, Lily-Rose 90
Diana, Princess 79
Dior, Christian 27, 114, *115*, 118, 133, 136
Ditto, Beth 136
Dogg, Snoop 136
Doherty, Pete 9, 60, 74, 104, 108–118, *119*, 124, 127, 136
Dolce & Gabbana 39, *39*
Donovan, Jason 62
Doukas, Sarah 24, *24*, 26, 27, 39, 49, 62, 91, 101, 113, 122, 123, 126
Drapers 126
drug abuse 42, 56, 58, 62, 80, 86, 104, 108–9
 "Cocaine Kate" 111, *111*, 113, 122, *122*
 "Heroin Chic" 9, 42, *49*
Dunn, Jourdan 138
Dylan, Bob 66

E
Elfering, Gert 138
Ellis, Perry 40
Emin, Tracey 90
England, Katy 127
Esquire 49, 127, 138
Evangelista, Linda 30, 52, 59, 62

F
Face, The 28, *28*, 31, 39, 52
Faithfull, Marianne 49, 79, 86, 88, *94*, 98, 99, 101, 108
Faludi, Susan 52
family
 brother (Nicholas Moss) 16, 17, *19*, 21, 26, 39, 66, 101, 108
 daughter (Lila Grace Moss Hack) 56, 89, 94, *98*, 104, 108, 122, 123, 133, 136, 138
 father (Peter Moss) 16, 19, 21, 26, 49, 62, 79, 94
 half-sister (Charlotte Moss) 79, 93
 husband (Jamie Hince) 129, *129*, *133*, 135–6, *136*, 138
 mother (Linda Moss) 16, 19, *19*, 21, 26, 37, 39, 59, 66, 88, 101, 104, 108, 123, 127
Farrow, Mia 80
Fenn, Sherilyn 62
Ferry, Bryan 9, 124, 133, *133*, 136
Figgis, Mike 124
Fox, James 138
Franklin, Aretha 62
Fred Joaillier 133
French, Jemima *70*
Freud, Lucian 94, *94*
Friel, Anna 79, 82
Frost, Sadie *70*, 79, 86, 94, 101, 102, 104, 108, 136

G
Gallagher, Liam 104
Gallagher, Noel 59, 74, 75, 77, 104
Galliano, John 26, 27, *27*, 30, *47*, 62, 118, 133, 136
Garratt, Sheryl 52
Gaynor, Gloria 62

Geffen, David 41
Gillespie, Bobby 94, 108, 111, 127
Gilliam, Terry 67, 76
Givenchy 65
Glastonbury Festival 111, *111*, 114
Goffey, Danny 104
GQ 32
Green, Philip 124, 126, *126*, 127, 129, 136
Gregory, Clark 32, 36, 37, 52
Grey, Jennifer 62
Guardian, The 52
Gucci 91

H
Hack, Jefferson 56, *88*, 90, 93, 94, 98, *98*, 99, 101, 103, 104, 108, 113, 122, 123, 127, 129, 133, 136
Harper's Bazaar 39, 40, 80, 82
Healy, Fran 108
Hince, Jamie (husband) 129, *129*, *133*, 135–6, *136*, 138
Houston, Thelma 62
Howells, Michael 101
Hume, Gary 90
Hume, Marion 52
Hunter, Rachel 24
Hutchence, Michael 62
Hynde, Chrissie 101

I
ID 49
Ifans, Rhys 89, 101, 104, 109
Independent, The 52, 91
International Women's Day lunch 102

J
Jacobs, Marc *40*, 138
Jagger, Georgia May 138
Jagger, Jade 79, *83*, 90
John, Elton 79, 111, 135
Jones, Allen 138
Jones, Grace 101
Jones, Mick 104, 108
Jopling, Jay 101, 108
Just Cavalli 133

K
Katz, Alex 102
Kensit, Patsy 79

INDEX

Khan, Jemima 126
Kidd, Jodie 86
Klein. Calvin 39–43, 47, 47, 49, 89, 114, 123
Knoxville, Johnny 104
Kraft, Neil 47

L
Lagerfeld, Karl *51*, 56
Lake, Jason 82
Langdon, Anthony 88, 90
Law, Jude 90, 94, 136
Lazareanu, Irina 118
Lebon, Mark 28
Le Bon, Yasmin 26, *70*
life and lifestyle
 acting and singing 59, 93, 101, 111, 113, *113*, 117, 133, 135, *135*
 anorexia scandal 9, 42, *49*, 52
 charity events 59, 66, 80, *80*, 126, *129*, 135
 drink, drugs and smoking 17, 19, 42, *49*, 59, 69, 74, 77, 79, 80, 86, 88, 89, 94, 111, *111*, 113, 122, *122*
 parties 31, *61*, 61–2, 66, 77, 98–102, 104, 108, 124, 129, 136
 rehab 62, 74, 82, 86, 123
 residences 15, 62, *63*, 66, 82, 86, 91, 108, *109*, 136
Little Britain 135, *135*
Longchamp 9, 114
Lowe, Pearl 79, 108
Lucas, Matt *135*

M
McCartney, Mary 101
McCartney, Stella 9, *70*, 89, 98, 101, 114, 133, *135*, 136
McDean, Craig 138
MacGowan, Shane 108
Macmillan, Dan 90, *90*
McPherson, Elle 62
McQueen, Alexander 101, *103*, 104, *105*, 123, *123*, 127
Madonna 89
Mail on Sunday 98, 102
Makatsch, Heike 104
Malkovich, John 66
Mandela, Nelson 80, *80*

Mango 133
Marilyn agency 79
Martin, Chris 102
Maselle, Gavin 80
Mathews, Meg 74, *75*, 77, 79, 89, 90, 101, 104
Meisel, Steven 86
Michael, George 133
Mirror, The 104, 111, 113
Mizz 27
modelling career
 awards 93, *93*, 124
 discovery as model 21, 24
 early photoshoots 26–9
 fees 9, 32, 41, 49, 82, 102, 114, 123, 126, *127*
Moorish, Lisa 104
Moriarty, Katie 108
Morris, Sarah 90
Morton, Samantha 90, 104, 108
Moss, Inger 79
Mosshart, Alison 129
Murphy, Davinia 79

N
Neilson, Annabelle *100*
New York Daily News 52, 74
New York Times, The 42
News of the World 109, 114
Nikon 114, 123

O
Obsession 42, 47, 49
Olympic Games, London 2012 – 138
One2One 82
O'Neill, Terry 39
Osbourne, Kelly 136

P
Pallenberg, Anita 49, 82, *94*, 108
Paltrow, Gwyneth *30*, 102
Paradis, Vanessa 40, 56, 74, 79, 82, 90
perfume advertisements 42, 47, *47*, 49, *51*, 91, *91*, 133
personal details
 character and glamour 15, 17, 27, 40–1
 cheekbones 24, 27
 figure 39, 42, 52
 hairstyles 17, *88*, 90
 height 26, 27, 39

Phoenix, River 58
Pirelli 123
Playboy 59, 138
POP 138
Pop, Iggy 59, 136
portraits 90, 94, *94*, 127
Prince, Richard 6

Q
Q magazine 6, *21*, 103
Quinn, Marc 14, *14–15*, 90, 124, 133

R
Ramirez, Twiggy 88
Rankin 90
Rees, Serena *100*, 101
Richie, Lionel 129
Rihanna 138
Rimmel 91, *93*, 114, 123
Ritts, Herb 42
Rizzoli New York *138*
Rock, Mick 124
Ross, David 26–7
Rourke, Mickey *58*
Rowland, Paul 39
Ryder, Winona 62

S
Sadgrove, Judy 52
St Laurent, Yves *51*
St.Tropez brand *138*
Schiffer, Claudia 49
Scott, Jackson 104
sexualization of children 42, 52
Shields, Brooke 40
Simenon, Paul 108
Sinatra, Frank 66, 79
SKATE Enterprises 49
Sorrenti, Davide 42, 79
Sorrenti, Mario 36–7, *36–7*, 39, 40, 42, 47, 49, *52*, 111
Springsteen, Bruce 66
statues 14, *15*, 124, 133
Stephenson, Jane 127
Stipe, Michael 108
Storm agency 24, *24*, 26, 39, 49, 52, 62, *65*, 79, 80, 86, 91, 101
Street-Porter, Janet 101
Summers, Ann 50
Sun, The 80, 108, 124
Sunday Mirror 109

T
Taylor, Davinia 104
Taylor-Wood, Sam 90, 101, 102, 108
Teller, Juergen 36
Testino, Mario 89, 99, *133*, 136
Thompson, Hunter S. 59, *61*, 67, 76
Tilberis, Liz 39
Topshop collection *19*, 114, 118, *122*, 124, 126–7, 129, 133
Turlington, Christy 30, 31, 52, 62, 80
Twiggy 39, 49, 102
Tyler, Liv *30*

V
Vanity Fair 31, 42, 76, 79, 138
Vauxhall 52
Vermorel, Fred 15
Versace 80, *80*, 86, 114, 133
Versace, Donatella 79, 86, 88
Versace, Gianni *78*, 79
Viper Room, The 58, 59, 61, 62
Virgin 114, 123
Vogue 39, 49, 50, 52, 82, 90, 103, 123
Vuitton, Luis 114

W
W magazine 102, 111, 138
Wahlberg, Mark 41, 42
"Waif, The" nickname 6, 66
Walker, Lisa 77
Weber, Bruce 6
Welch, Justin 89
Westwood, Vivienne 52, 102, 124, 136
Whitehead, Adam 133
Wintour, Anna 50
Women Management 39, 79
Wood, Jesse 79, *83*, 89
Wood, Jo 74, *83*, 101
Wood, Ronnie 74, 79, *83*, 101, 104

Y
Yurman, David 114

Z
Zara 86, 102, *102*

Acknowledgements

Bibliography

Addicted To Love: Kate Moss, Fred Vermorel, Omnibus Press, 2007.
Kate Moss: The Complete Picture, Laura Collins, Sidgwick & Jackson, 2008.
Kate Moss: The Making Of A Brand Icon, Brandon Hurst, Top Spot Publishing, 2011.
Kate Moss Machine, Christian Salmon, Editions La Découverte, 2009.
Editions of: *Vanity Fair, Q, Esquire, Dazed & Confused, The Face, Harper's Bazaar, i-D,* and various newspapers.

Picture Credits

The publishers would like to thank the following sources for their kind permission to reproduce the pictures in this book.

Key: t=Top, b=Bottom, c=Centre, l=Left and r=Right.

Page 4 Getty Images/AFP; 7 Rex Features/David Fisher; 8 Rex Features/Mark Large/Daily Mail; 10-11 The Advertising Archives; 12 Rex Features/Richard Young; 14 Rex Features/Glenn Copus/Evening Standard; 15 Corbis/epa/Andy Rain; 16 Rex Features/Today; 17 Rex Features/Today; 18 Rex Features/ Richard Young; 19 Rex Features/Richard Young; 20 WENN; 21 Rex Features/Bill Orchard; 22 Rex Features/Vic Singh; 24 Rex Features; 25 Rex Features/Vic Singh; 26 Camera Press; 27 Camera Press; 28-9 The Face Magazine, Bauer Media; 30 Getty Images/WireImage; 31 Camera Press; 32 Contour By Getty Images/Michel Haddi; 33 Contour By Getty Images/Michel Haddi; 34 Rex Features/Vic Singh; 36 Getty Images/Time & Life Images; 37 Getty Images/WireImage; 38 Getty Images/Terry O'Neill; 39 Camera Press; 40 Camera Press; 41 Camera Press/Denzil McNeelance; 42 Press Association Images/Charles Guerin/ABACA USA/Empics Entertainment; 43 The Advertising Archives; 44 Rex Features/Neville Marriner/Daily Mail; 46 The Advertising Archives; 47 The Advertising Archives; 48 Getty Images/Time & Life Images; 50l Rex Features; 50r Rex Features; 51 Camera Press; 53 Camera Press; 54 Rex Features; 56 Camera Press; 57 Rex Features; 58 Getty Images/NY Daily News; 59 Rex Features/Dennis Stone; 60t Getty Images/FilmMagic; 60b Press Association Images/Tammie Arroyo/AFF/EMPICS Entertainment; 61 Rex Features/DAVID ABIAW; 63t Corbis/Sygma/Robert Knight; 63b Corbis/Sygma/Robert Knight; 64 Press Association Images/Louisa Butler/PA Archive; 65 Camera Press; 67 Press Association Images/Laurent Rebours/AP; 68 Camera Press; 69 Camera Press; 70 Camera Press; 71 Camera Press; 72 Rex features/Richard Young; 74 Press Association Images/ Cruisepictures/EMPICS Entertainment; 75 Rex features/Sipa Press; 76l Rex features/Richard Young; 76r Rex Features/Richard Young; 77 Rex Features/Sipa Press; 78 Rex Features/Ken Towner/Evening Standard; 80 Rex Features/Ken Towner/Associated Newspapers; 81 Rex Features features/Leon Schadeberg; 82 Rex Features features/Ken Towner/Evening Standard; 83 Press Association Images/Mitchel Sams/EMPICS Entertainment; 84 The Advertising Archives; 86 Rex Features/Richard Young; 87 Rex Features/Richard Young; 88 Rex Features/Steve Wood; 89 The Advertising Archives; 90 Camera Press/Tim Douglas; 91 The Advertising Archives; 92 Rex Features/Richard Young; 93 The Advertising Archives; 94 Rex Features; 95 The Bridgeman Art Library/©The Lucian Freud Archive/Private Collection; 96 Rex Features/Stephen Butler; 98 Rex Features/Stuart Atkins; 99 Rex Features/Cavan Pawson/Associated Newspapers; 100 Rex Features/CHAPMAN; 101 Getty Images/David Westing; 102 The Advertising Archives; 103 Getty Images/Dave M. Benett; 105 Rex Features/Richard Young; 106 Rex Features; 109 Rex Features/OLI SCARFF; 110 Rex Features/Anna Barclay; 111 Mirrorpix; 112 Getty Images/Dave M. Benett; 113 Rex Features/CGE/Olycom SPA; 114 Rex Features/Clive Postlethwaite; 115 Getty Images/Matt Cardy; 116 The Advertising Archives; 117 Rex Features/Andrew Davidson; 118 Rex Features/Jonathan Hordle; 119 Rex Features/Jonathan Hordle; 120 Rex Features/Arnold Slater; 122l Rex Features/Jeremy Selwyn/Evening Standard; 122r Getty Images/AFP; 123 Getty Images/Dave M. Benett; 124 Press Association Images/Charles Guerin/ABACA USA/Empics Entertainment; 125 Getty Images/Gamma-Rapho; 126 Getty Images; 127 Rex Features/Ray Tang; 128 Getty Images/WireImage; 129 Rex Features/Richard Young; 130 Getty Images/Dave M. Benett; 132 The Advertising Archives; 133 Press Association Images/Suzan/Suzan/EMPICS Entertainment; 134 Camera Press/ED/CE/Comic Relief; 135l Getty Images/Dave M. Benett; 135r Rex Features/Richard Young; 136 Rex Features/Beretta/Sims; 137 Getty Images/FilmMagic; 138 Rex Features/Richard Young; 139 Rex Features/Richard Young; 140-1 Camera Press/ED/CE/St Tropez.

Every effort has been made to acknowledge correctly and contact the source and/or copyright holder of each picture and Carlton Books Limited apologises for any unintentional errors or omissions, which will be, corrected in future editions of this book.